THE WILD COAST

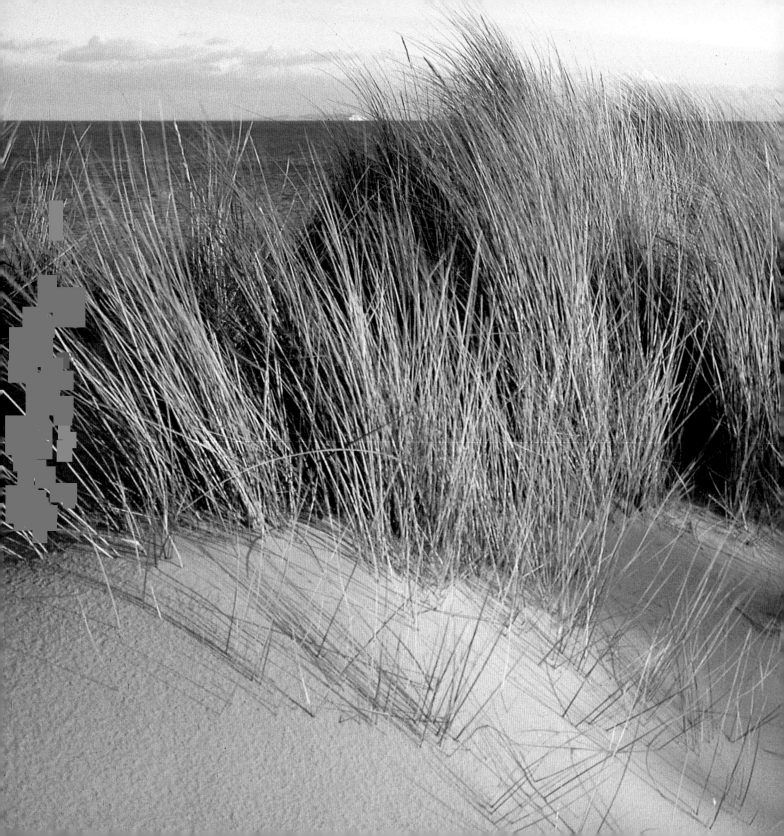

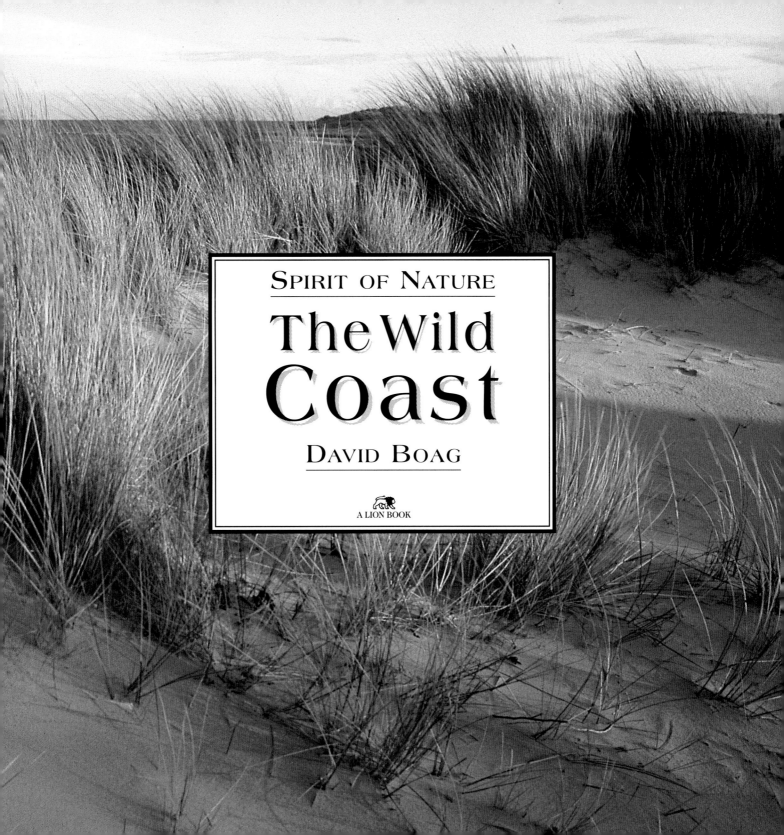

SPIRIT OF NATURE

The Wild Coast

David Boag

A LION BOOK

Introduction

Perhaps because it is so difficult for humans to tame the elements of wind, waves and ceaseless tide, I think of the coastline as containing the wildest parts of the British Isles. Apart from a narrow strip around the coast it seems as if most of the land has been cultivated, grazed or managed at some time in history. I imagine the wild coast as representing what nature was created to be like.

Walking along a section of the coast for the first time, I am always excited by the variety of scenery on offer. One can never be certain if the cliff will plunge down into a sandy cove, or if a long shingle beach will present itself. Rock pools, caves, spits of land and stacks of rock, all this coastal scenery is the result of the interaction of the sea with the land.

Animal life is controlled by the tide, a constant ebb and flow — twice a day — every day. It is the great heartbeat of the ocean and all life moves with its rhythm. Parts of the coast seem hostile and a difficult place to live, especially the turbulent zone between the tides, where life is constantly in flux. Whether shifting sand dunes or a bare cliff face, every area has its own flora and fauna. Plants have problems of their own with constant sea spray and, at times of high tide, flooding by salt water. Strangely, even though the endless ocean may be only a few metres away, a lack of water is a problem for many plants. Little crevices in a bare rock face will not hold water for long and sand dunes soon heat up and dry out. Nevertheless, in every nook and cranny life abounds.

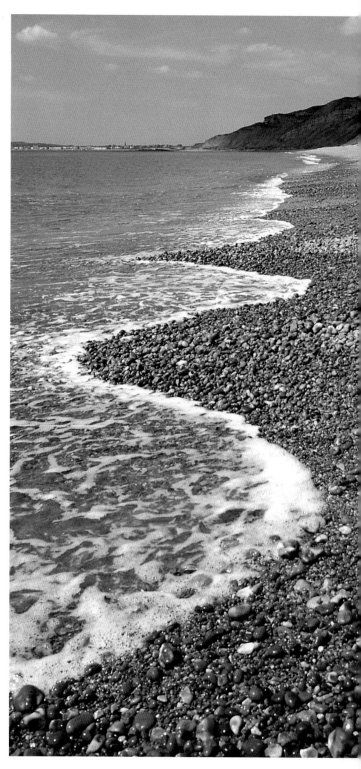

One of the greatest features of the wild coast is the abundance of bird life. This is a direct result of the productivity of the ocean. Beneath the waves a chain of life exists that few of us are privileged to observe. We can, however, see the result where countless thousands of birds choose to nest on the cliffs and beaches. Here they can draw on the plentiful reserves of the sea. Indeed many sea birds only come to land because they cannot lay their eggs on the ocean. Being so vast, the sea is a very stable and reliable environment and it is only careless or foolish humans that are able to damage the wealth of life to be found within its depths.

Part and parcel of how I react to the natural world that surrounds me are my Christian beliefs. I feel it helps me maintain a great enthusiasm for creation. The wild coast moves me by its raw beauty; and the power and mystery of the ocean never ceases to amaze me.

Nothing in nature stands still, nothing remains the same. I do not believe it was ever meant to. Having set things in motion God allows the natural world to develop and take its own course, just as parents delight to see their child mature and change.

For me God is creative as well as the creator— after all, where did we get our creativity from? I hope that as you turn the pages of this book you will discover, with me, something of the creator.

When they are in the water, grey seals are well known to be lithe, agile and fast. Not so well known is the tuning that enables a seal to dive to depths of 90 metres (50 fathoms), and remain underwater for up to half an hour.

It seems incredible that just before diving the seal exhales, almost emptying its lungs. As it dives its heart rapidly slows until it is beating at only a third of its normal speed and the flow of blood to the heart is virtually stopped by a special group of muscles. Oxygen is stored in the unusually high volume of blood in the body and also in the muscles. This is only a small part of the remarkable design that perfectly equips a seal for life in the ocean.

However, seals still need to haul out onto land to rest, moult and have their pups. To avoid disturbance by humans when they are breeding, grey seals congregate on remote islands or in caves that have difficult access from the land.

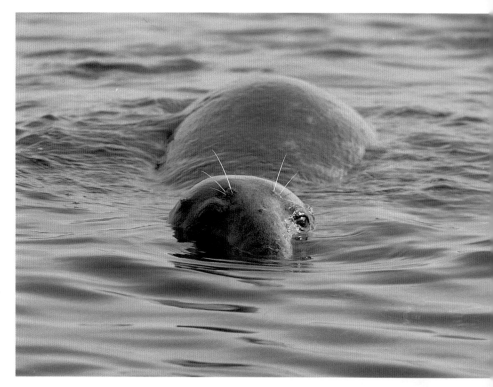

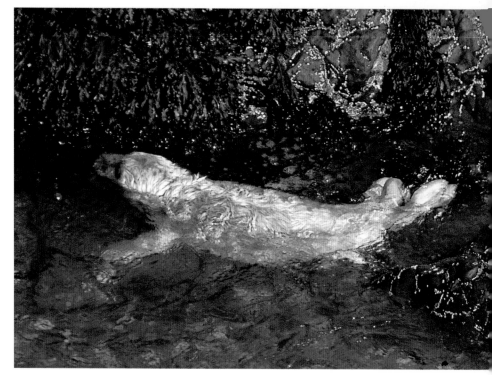

A full-grown male grey seal may measure 2.3m in length and weigh 300kg, making it the largest British mammal. Although males may live only 25 years, a female may live over 40 years.

Constant battering from the ocean creates caves in the sea cliffs. Even though the entrance may appear small, the interiors of some of these caves may be huge — large enough for many seals to haul out to rest on underground beaches.

When they are born grey seal pups weigh about 15kg and are covered in white infant fur. They are more or less land-based for their first two and a half weeks of life while their mother feeds them. However, they cannot resist playing in the shallows, bobbing about in the swell, investigating rocks and seaweed.

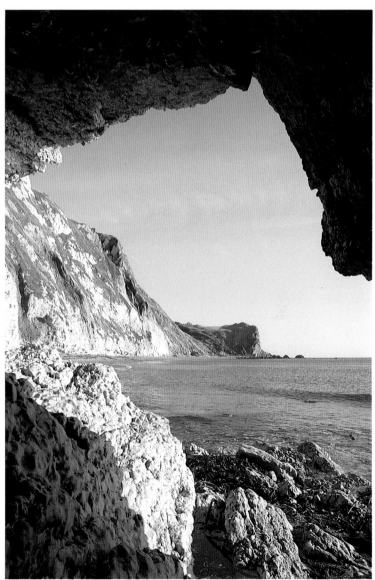

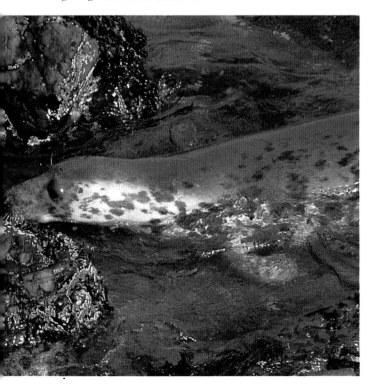

The habitat of sand dunes is naturally one of the most fragile places on earth. This strange environment is formed as the sun and sea breeze dry the sand on the beach. The sand is blown by the wind until trapped by a minor obstruction, causing it to pile up into miniature drifts. Seaweed is also trapped in the drift and as it decomposes it provides nutrients for the first plants to colonize. Typically these are plants with strong, creeping roots systems; the main plant being marram grass.

The further the sand dunes stretch from the beach, the more stable this habitat becomes. However, it is strange to consider that the wind which created the dune will almost certainly, one day, destroy it.

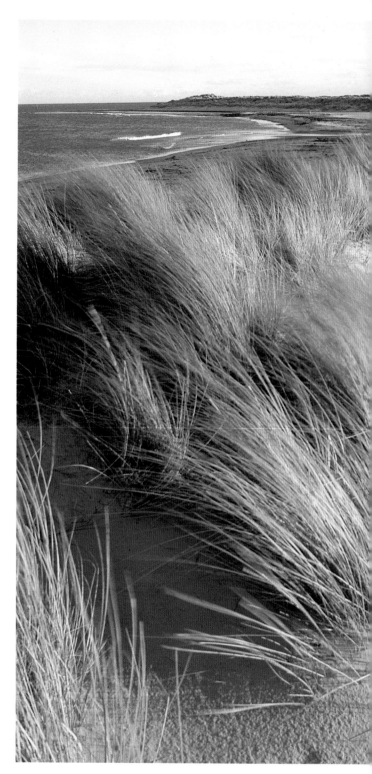

The wind sweeps across the sand leaving infinitely varied patterns of ridges and furrows — the giant fingerprints of the wind.

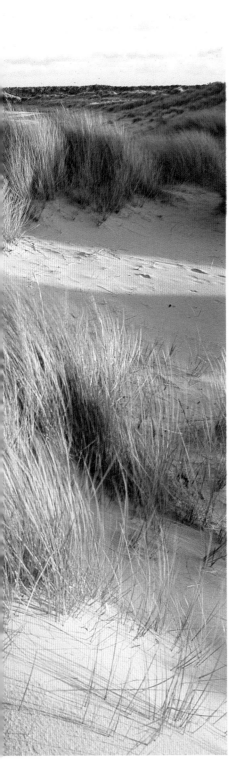

Marram grass sends its roots down several feet into the sand as it grips this fragile environment. The stiff leaves trap more and more sand, resulting in the marram grass producing long side shoots. It is claimed that in one year this incredible grass can spread up to 10m. The effect is to deepen and stabilize the dune.

As wind-blown seeds are trapped in the shingle, marram grass becomes established. Constantly buffeted by gales and threatened by high tides, it persistently clings on to the edge of existence.

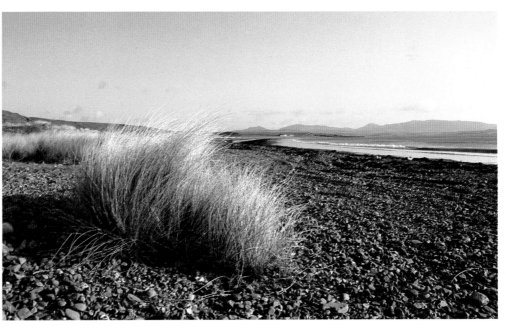

It is difficult for any living thing to exist in the constantly shifting environment of a sand dune. If plants are to thrive they need to send down deep roots in their attempt to stabilize the sand, as well as in their search for fresh water.

If it is such a difficult place to live, the question arises, why live there? It is possible that there is much less competition for space in the dunes. However, when the dunes become stabilized and other plants are able to move in, the original colonists are squeezed out. So by stabilizing the dunes they cause the downfall of their own existence.

10

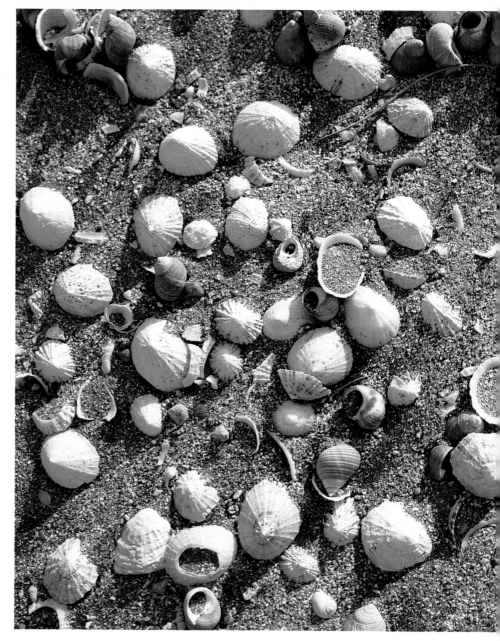

Sea-spurge is one of the species of plants to thrive in the dunes.

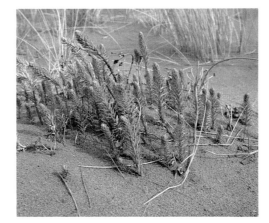

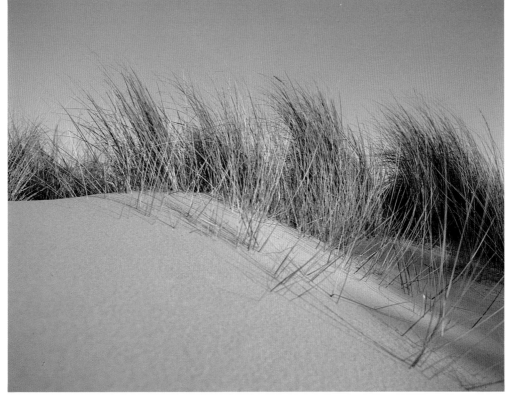

As the wind tugs and pulls at the marram grass more and more sand is blown from the beach. The wind-blown sand is trapped by the grass, and a great hill of dry, shifting sand is created.

Few of us can be unaware of the delights to be discovered in a good rock pool. As infants we searched the still water for any sign of movement, but as we grow older we seem to need the excuse of children or grandchildren to play with. Rock pools provide such a variety of life, ranging from shrimps to whelks, fish to starfish and many different species of seaweeds.

One of the best ways to view a rock pool is at night, with the aid of a torch. Many creatures that lie hidden during the day emerge to feed and shrimps can be easily spotted as their eyes shine brightly in the torchlight. Limpets, that seem like immovable bits of rock, come alive as if by magic and begin moving over the rocks, grazing on the plant life.

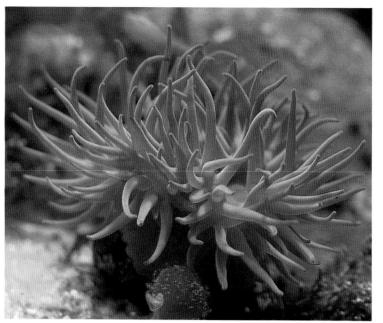

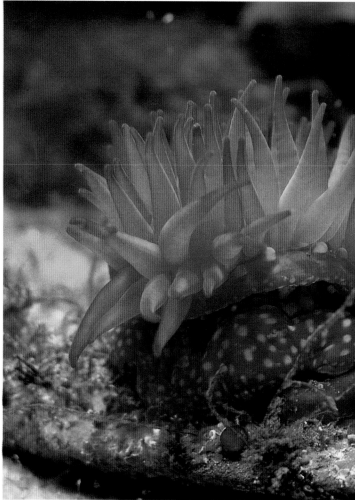

Snakelock anemones can be discovered in sunlit rock pools. Unlike many anemones they cannot withdraw their long wavy tentacles even when out of water.

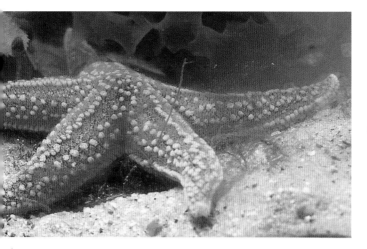

It is remarkable that common starfish can prise apart shells of mussels, upon which they feed. Equally amazing is that if an arm is broken off, the starfish is rapidly able to grow another to replace it.

Hermit crabs often use the shell of a whelk to protect their soft bodies. As they grow, their homes become too small, so they are constantly on the lookout for a new and larger residence.

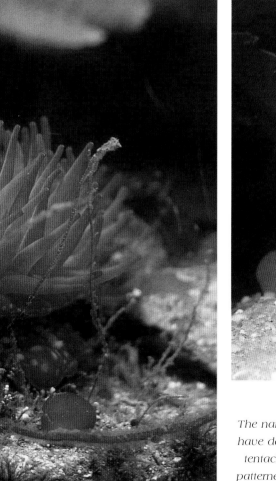

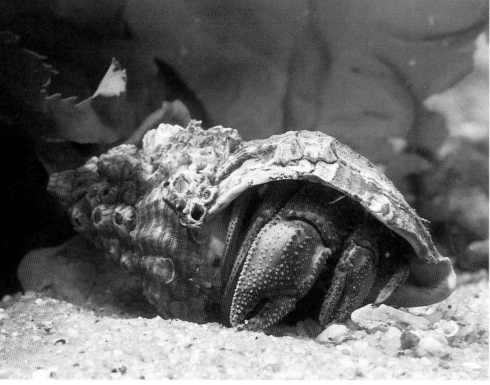

The name of the strawberry anemone must have derived from its appearance when its tentacles are contracted. The red base is patterned with yellow dots like the seeds in a strawberry.

Where the vast ocean meets solid rock we see nature at its most dramatic and powerful. It is like a natural demonstration of 'an irresistible force meeting an immovable object'. Awesome cliffs and jagged carved rocks are the result, illustrating that once the elements were set in place they were never meant to be static. It is a world that demonstrates creative powers in action, that continue day after day.

In some situations the battering power of the ocean discovers a patch of softer rock and a cave is carved out. On other occasions hard rock ramparts are breached and constant erosion produces a secret cove. As the years progress the coastline will gradually be changed but where solid, towering cliffs plunge into the ocean, this is most difficult to imagine.

14

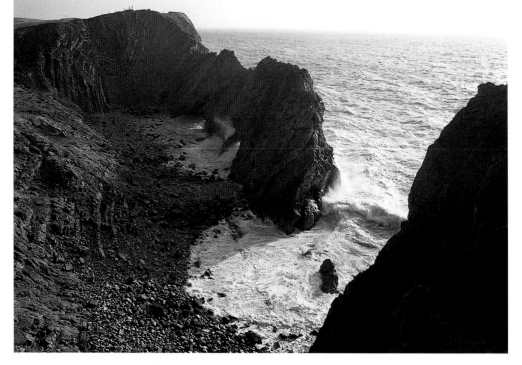

Huge cliffs on the northern Scottish coast seem impregnable to both time and tide. However, time and tide will tell!

Through thousands of years the relentless sea has battered away at the hard rock until it broke through and scooped out the softer rock behind, to form Stair Hole in Dorset.

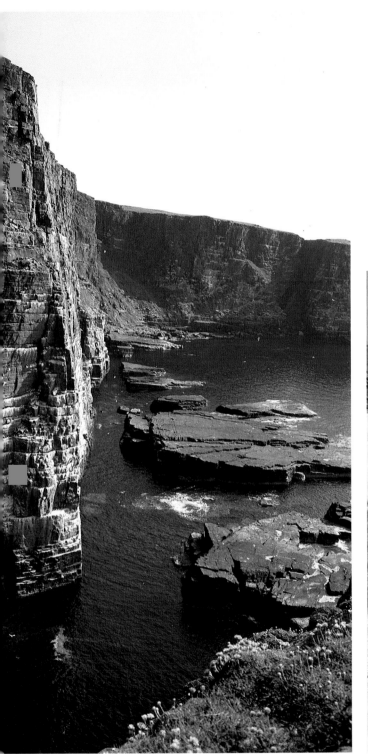

Fragments of rock broken from the cliffs by constant wave action are worn into even smaller particles. Eventually they may be swept inland again by underwater currents and the action of the tide, creating sandy beaches.

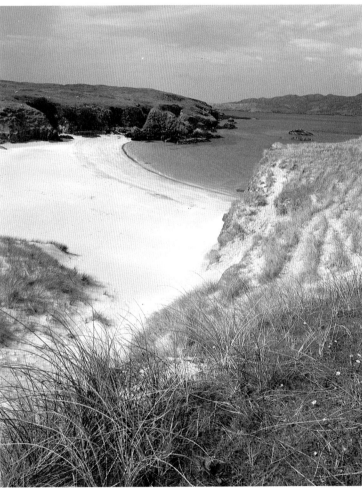

As the sun disappears below the horizon the atmosphere subtly changes. Colour is drained from the flowers on the cliffs and the rocks glow with the orange light of the setting sun. Birds can still be recognized by their calls, shape and movement but no detail in the plumage can be seen. As darkness finally closes in, a new set of creatures takes the stage. Toads, mice and voles creep from their daytime hideaways and the air may be filled with a fluttering of wings and strange eerie cries.

Several species of birds arrive at their breeding colonies under cover of darkness, in particular shearwaters and petrels. They locate their nests, and mate, by their distinctive calls which, to the human ear, can seem a frightful sound. Indeed, it was said by some ancient sailors that certain islands were the home of demons.

On a clear night the universe is revealed by the countless stars and one cannot help feeling small and insignificant on our little planet.

A headland becomes little more than a silhouette of subtle shades. Solid land and shimmering sea are changed to an ethereal view by the setting sun.

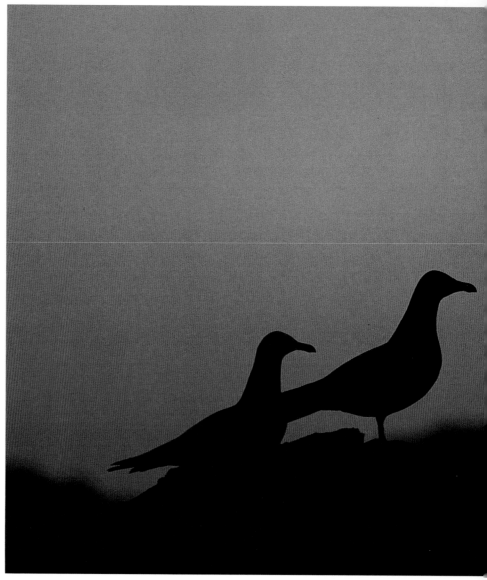

Silhouetted against a sunset sky a pair of gulls look almost innocent, nevertheless they are still on the look out for any vulnerable creature that should come their way. Not until it is quite dark will their clamouring calls fall silent.

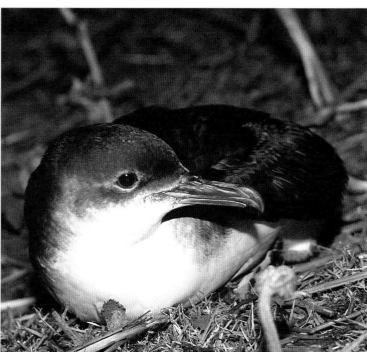

A colony of Manx shearwaters may contain hundreds of thousands of birds, but a visit during the day will be most disappointing for not one will be seen. They are feeding miles out at sea, or deep underground in their nest burrows. Not until the gulls have roosted will the Manx shearwaters appear. They are useless on the ground, so they arrive under cover of darkness to avoid the predatory gulls.

For me few other creatures evoke such a feeling of the wild as the otter. To discover an otter on a remote Scottish loch or a tumbling river provides an exhilarating, lasting memory. Probably as a result of persecution in the past, otters are rather secretive creatures, especially during the daylight. It therefore follows that they are most easily seen at dusk and dawn.

Overland they can move quite swiftly with a hunch-backed, lolloping gait. It is when swimming that otters really seem to be in their element; moving with graceful ease, twisting and turning in the water, they are as at home underwater as on the surface. They are well designed for amphibious life with strong webbed feet and a thick coat of fur. The outer layer of guard hair covers and protects the under-fur which is soft and extremely dense. As the otter dives a layer of air is trapped in the under-fur, and this insulates it from the cold and wet; the otter's skin never becomes wet.

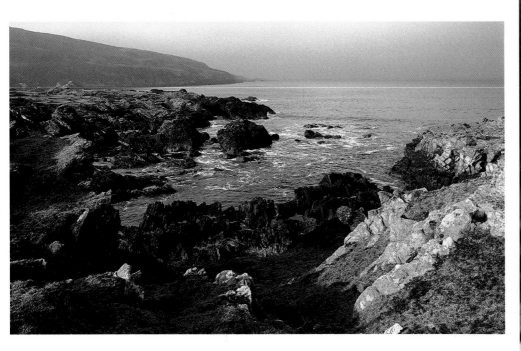

Typical otter habitat is far removed from the activities of people: wild, remote places, adding to the otter's mystery and befitting such a splendid animal.

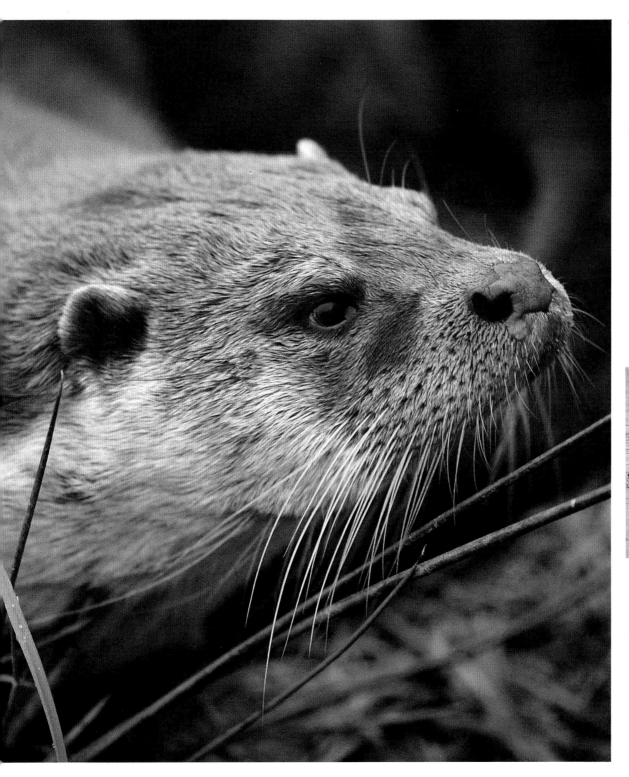

The head of the dog otter shows the wealth of stiff whiskers that are very sensitive to touch. They enable the otter to locate its prey even when visibility is poor in murky water or in poor light.

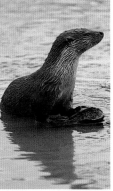

Otters are equally at home in salt or fresh water and many otters include both within their hunting range.

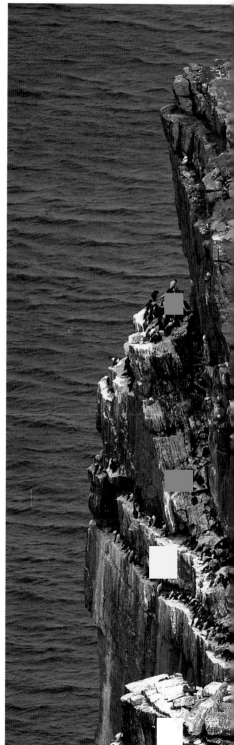

Rock stacks off the coast almost always attract large numbers of sea-birds. They make ideal locations for breeding colonies of many different species: gulls, petrels, shags and auks, to mention a few.

Both the razorbill and the guillemot are members of the auk family, and their appearance demonstrates a family likeness. They use stacks to nest because they are inaccessible to mammal predators and rarely disturbed by humans.

On the stack each species has a different favourite nest location which keeps the conflict between the different birds to a minimum. Auks and fulmars make use of the ledges while kittiwakes glue their nests onto near-vertical faces. Storm petrels will nest in the cracks between the rocks and shags may take over the penthouse suite at the top.

This arrangement works well, except that there are often battles between individuals of the same species as they squabble over a favoured nest site.

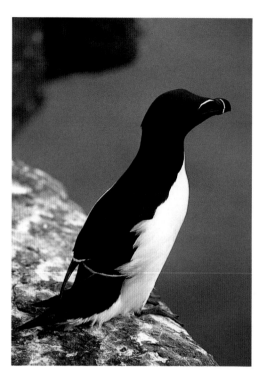

Razorbills tend to select smaller ledges which are just large enough for a pair to raise their chick.

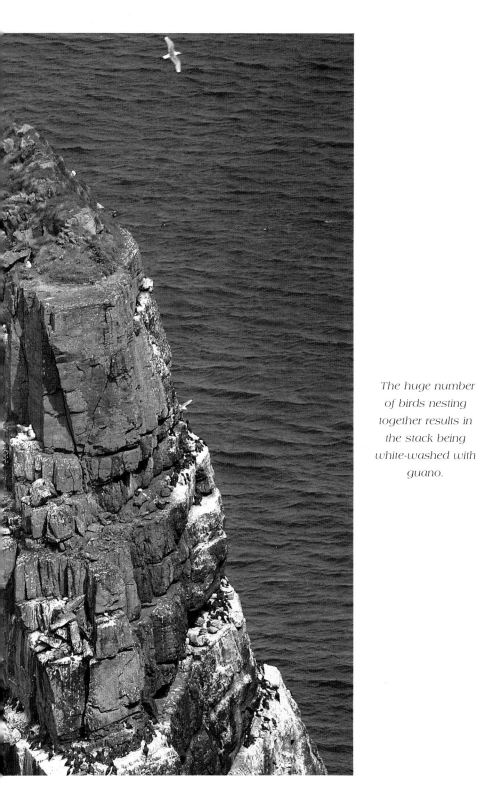

Guillemots choose the long narrow ledges where rows of them cram together in sea-bird squalor.

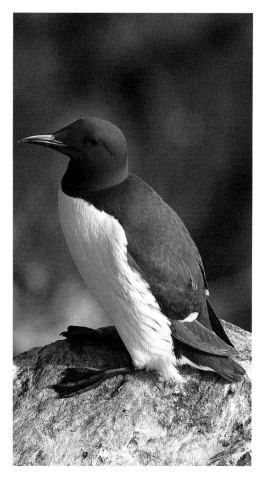

The huge number of birds nesting together results in the stack being white-washed with guano.

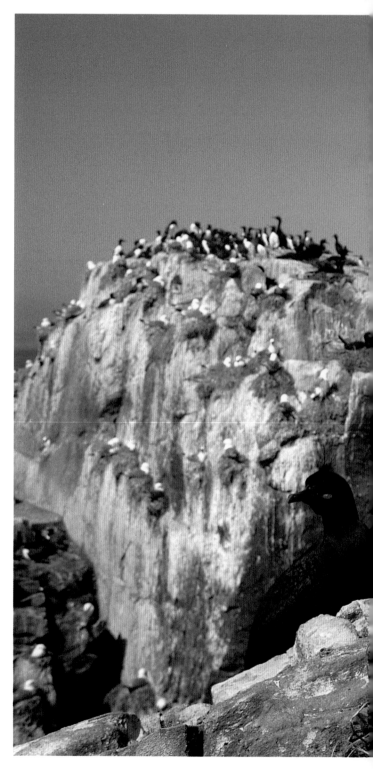

S hags select quiet rocky coasts as nest locations. They choose mainly to nest in colonies but single nests can also be found. The shag makes its nest from any flotsam it can gather — from seaweed to bits of rope and string. They have discovered that one of the best places to find nest material is in a neighbour's nest, and quite often a tug of war develops over a choice item.

Unlike many other sea birds the shag does not travel hundreds of miles out to sea or spend weeks away from the coast. Its plumage is not as water-repellent as in most species of sea bird and so it needs regularly to come to land to dry out its feathers. A favourite drying location may be visited by dozens of shags as they stand upright, with wings outstretched, allowing the breeze to blow through their plumage.

22

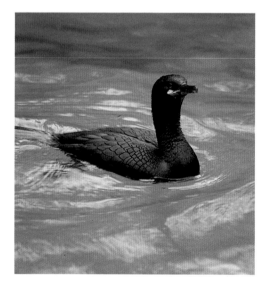

Three or four eggs are laid in the nest and both sexes take turns to incubate them. Incubation lasts for a month before the little chicks hatch. They are naked at first but soon become covered in brown down. They grow rapidly and fly when less than two months old.

On the sea the shag is an efficient swimmer and as it dives underwater in pursuit of fish, its powerful webbed feet propel it at great speed.

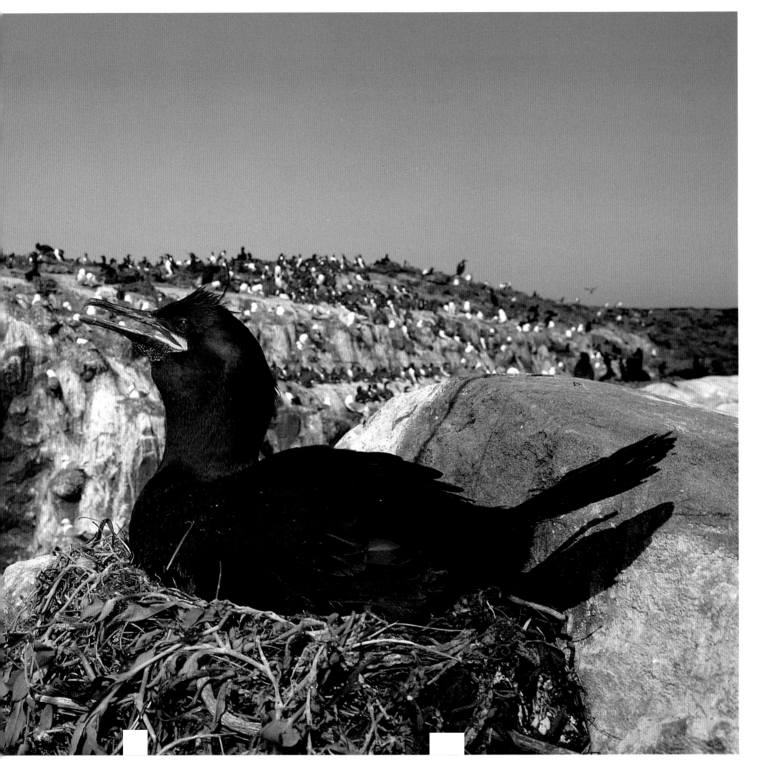

Great and Arctic skuas are often described as pirates of the north. They are large and powerful birds that patrol the skies looking for suitable victims. Both species are fast and remarkably agile in the air and they use their ability to chase and harass other sea-birds unmercifully. Eventually the victim is forced to drop or disgorge the food it is carrying and the skua takes it as its own.

Being the larger of the two, the great skua is even more violent and is capable of catching and killing other small sea birds, such as puffins. Having acquired a meal, they do not 'own' it until it is swallowed — skuas will even rob prey from their own kind.

Skuas defend their nests even against humans. With lightning speed they fly directly at the intruder, sometimes even making physical contact, which can be most painful.

Nevertheless, in spite of their ill-bred qualities, they are dramatic and exciting birds to watch.

Arctic skuas have two distinctly different plumages. Sometimes they are all dark brown (dark phase) whilst on other occasions they have a creamy body with dark wings and cap (pale phase).

24

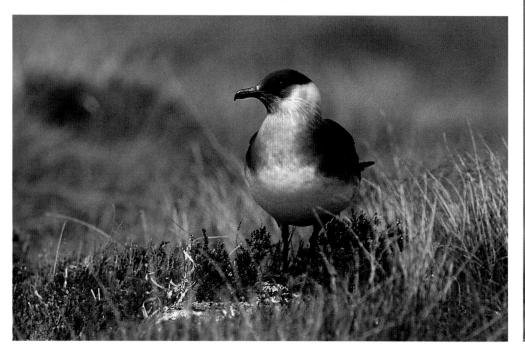

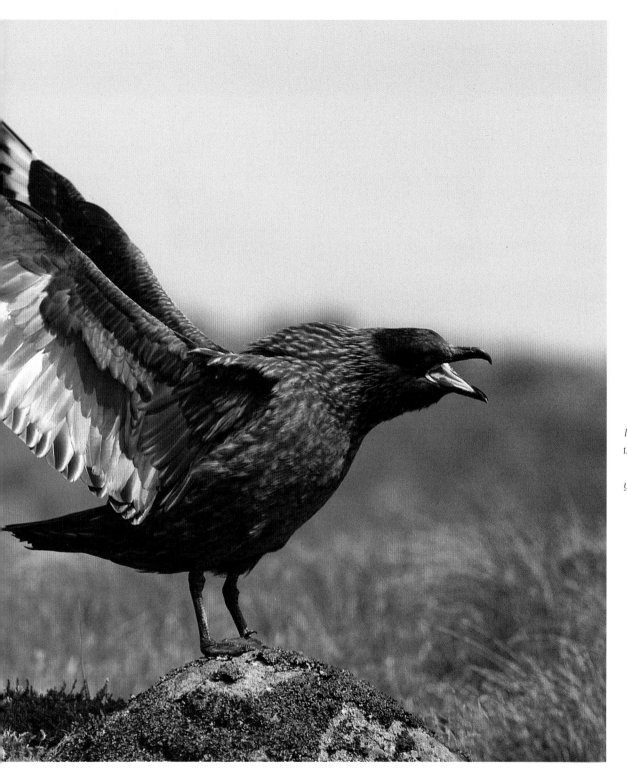

The great skua extends its wings signalling its territorial rights to a nest site. Eggs are laid to coincide with the hatching of other sea birds because young birds or eggs make easy prey. The skua can also be assured that other sea birds will be bringing food to their young, which the skua can steal.

Looking as if they were crafted by a great sculptor's hand, huge pinnacles of rock and massive arches decorate the edge of the ocean. Powerful forces that began so long ago continue to erode the land, defining the coastline.

Dependent upon the nature of rock and flaws or faults within its surface, the infinitely variable forms are carved. Even within a few miles the rock type can change so dramatically that both colour and shape create new wonders for the eye to enjoy.

Durdle Door and Old Harry Rocks in Dorset are only a few miles apart and both are the result of the same eroding elements. Durdle Door has been formed in Jurassic limestone whilst Old Harry Rocks have been fashioned out of chalk. It's worth remembering that the same eroding elements that formed them will eventually destroy them.

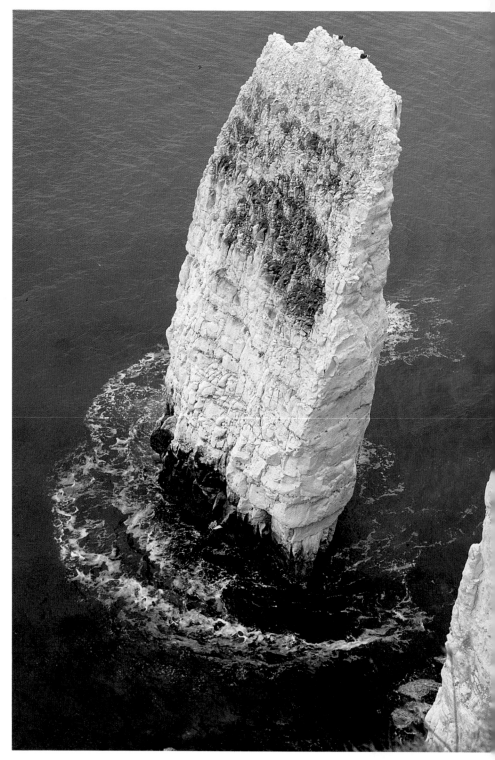

At Durdle Door the pounding waves found a minute weakness in the rock which they pursued until a hole was formed. Year by year the hole grows larger and one day it is inevitable that the bridge will collapse.

Old Harry Rocks were carved from the cliff by the constant pounding of the sea, and then wind and rain hewed the chiselled edges into shape.

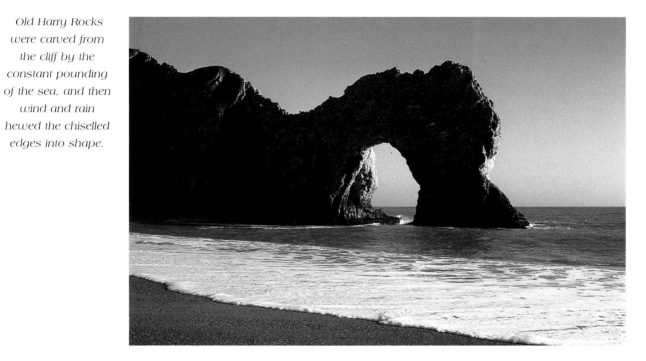

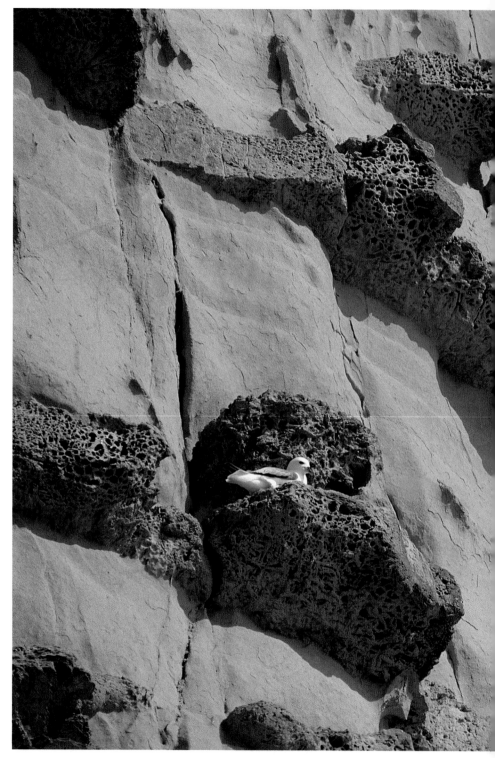

The variety of rock types found around the coast ensures that the scenery is always new and exciting. Even those who understand little about geology can't help being impressed by the variety of colour, texture and shape of these magnificent natural sculptures. Some cliffs are as white as chalk (literally) whilst others are as black as coal. Some outcrops seem as hard and grey as steel whilst others appear warm and yellow.

In some areas the rock is rough and jagged, yet not far away boulders may feel smooth to the touch. Some shapes are rounded, some shapes are sharp. There is so much variety in what the uninformed refer to as 'rock'.

Dwarfed by the size of the cliff a fulmar sits on a ledge of rock. It is possible that it is incubating an egg but, typical of fulmars, the inaccessibility of the ledge makes it impossible to be certain.

Rising vertically from the beach the high cliffs catch the midday sun. Inset within these distinctive sandstone cliffs are rocky coral outcrops which make splendid nesting ledges for sea birds.

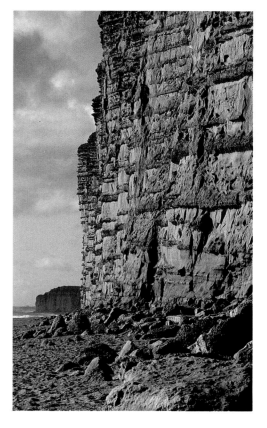

The kittiwake is a slender, elegant gull that seems to have few of the unpleasant habits of other gulls. They do not feed on rubbish tips, rob other birds of their eggs, or prey upon weaker species. Kittiwakes are true sea birds, only coming to land to lay their eggs and raise their chicks. Throughout the whole of a kittiwake's life the sound of the sea is within its hearing, because they nest in large colonies on cliffs overlooking the ocean.

In some locations many hundreds, or even thousands of kittiwakes gather together to nest in traditional nest sites and their clamouring calls are always echoing around the cliffs. During the nesting season they constantly fly to and from the ocean where they feed upon small fish snatched from just below the surface.

Once the chick is independent the kittiwakes will leave the cliffs to wander the vastness of the northern seas throughout the autumn and winter months, returning the following spring to begin the cycle all over again.

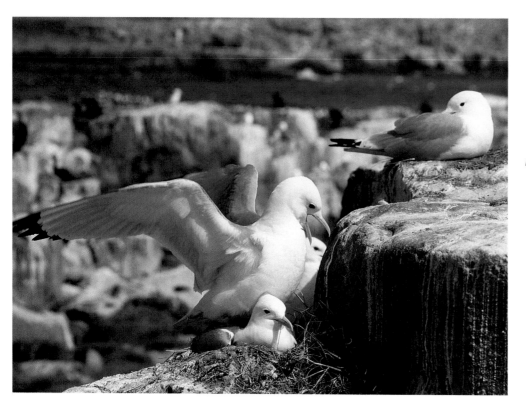

As a result of mating the female kittiwake will lay one, two or occasionally three eggs. They are incubated for just over three weeks before the fluffy grey chicks hatch. The nestlings remain in the nest for four weeks before beginning their life on the ocean.

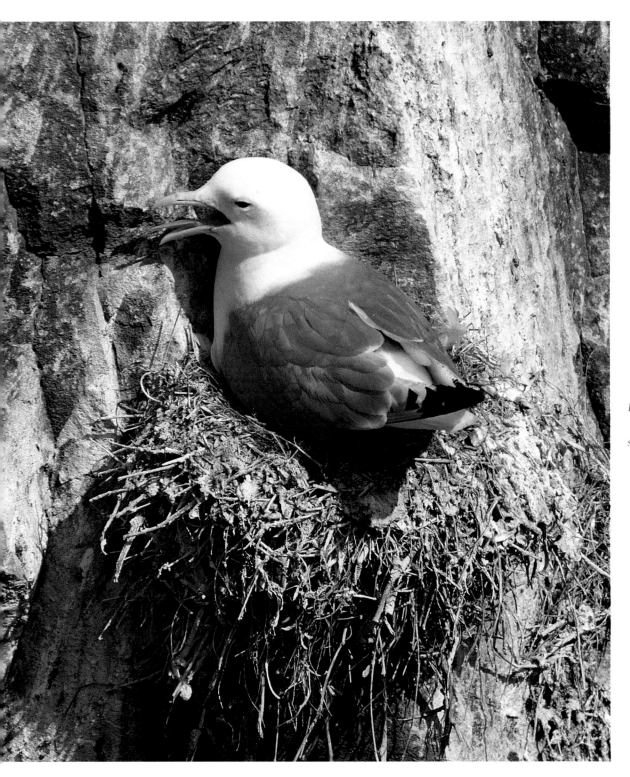

Sometimes a kittiwake may select a nest ledge that is so small it seems as if the nest is glued onto a sheer rock face. On the exposed cliff face there is no respite from the sun and the kittiwake pants in the heat as it incubates its eggs.

The fulmar is a member of the petrel family, and they are recognizable by their distinctive beaks. The beaks are made of a set of horny plates and the joints are easily visible. The main feature, however, is the horny tube that lies on top of the beak which gives the family the name of 'tube-noses'. The function of the tube remains a mystery — some claim it is connected with excreting salt, others consider that it enhances the birds' sense of smell, and yet another theory is that it may assist speed assessment. No doubt the debate and research will continue.

32

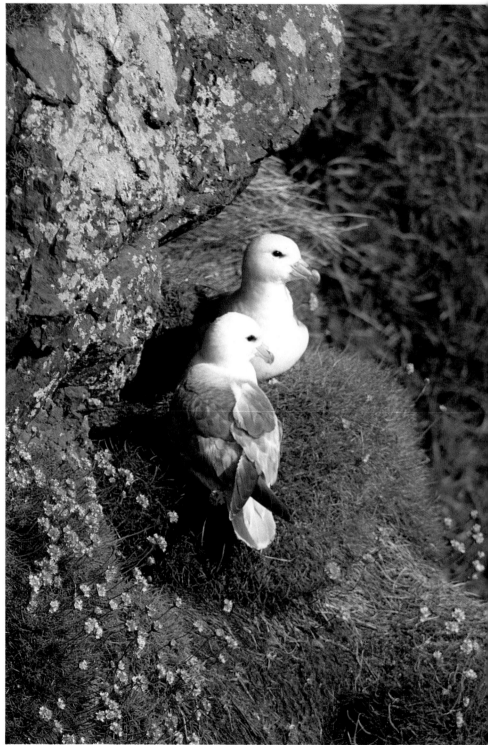

The only reason fulmars come to land is to nest. Along with many other species of sea birds they choose cliff ledges on which to lay their eggs. This enables them to take to the air quickly and effortlessly.

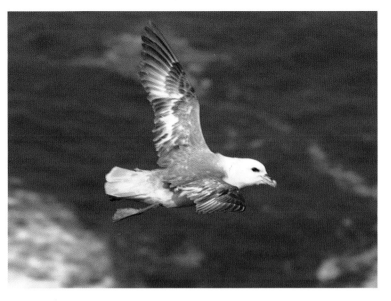

The fulmar has wonderful mastery of the air currents. Even in the strongest wind the fulmar is able to skim a cliff face with precision.

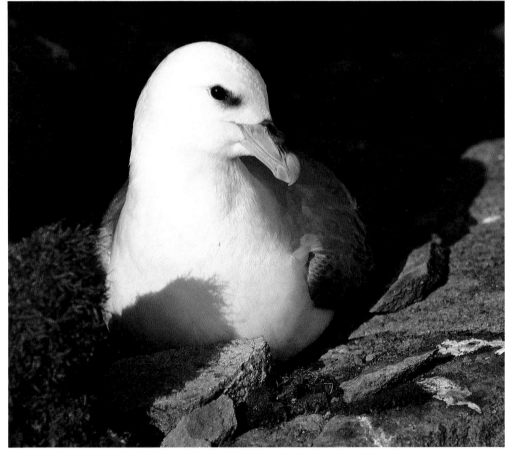

The stable environment of the ocean enables fulmars to live a long life (possibly thirty years). However, they lay only one egg each year. From the day the egg is laid until the chick fledges is three and a half months, and as a result the fledglings are well grown and strong when they leave for the ocean.

Seeing a large sea bird colony is a spectacle of natural history that remains in the memory for many years. At first one cannot help being impressed by the wild scenery — towering cliffs of solid rock. Then, carried by the sea breeze, the smell and sound of the birds greets you: the sickly, pungent smell of the guano from thousands upon thousands of birds. The cliffs, that you know should be dark rock, are whitewashed with the birds' excrement. So many birds make such a clamouring of sound that one cannot comprehend how any individual calling bird could be recognized by its mate.

At first it is only the hundreds of birds in flight that are noticeable, and the full impact of the colony does not hit you. It is not until you follow one of the flying birds to the cliff that you gasp in amazement, realizing that you are actually looking at many thousands, not hundreds, of birds.

The most prolific of these birds is the guillemot. They sit on the ledges facing the cliff so their dark backs blend into the wall of rock. The numbers of these birds are an indication of the productivity of the surrounding sea, because they feed largely on fish.

34

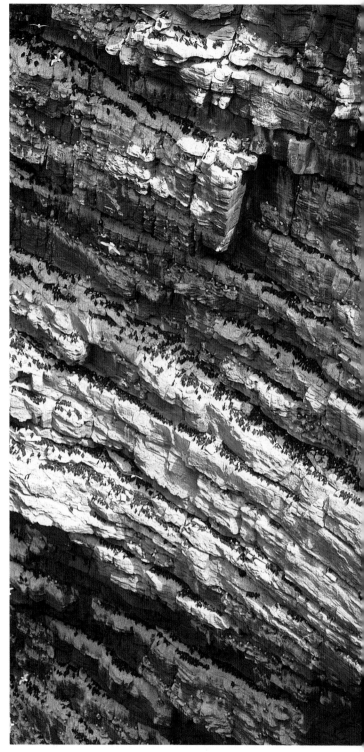

In this photograph there are over 2,800 guillemots visible. Others will be hidden from view and yet more will return to the cliff later. Over 600 other nesting sea birds are also visible.

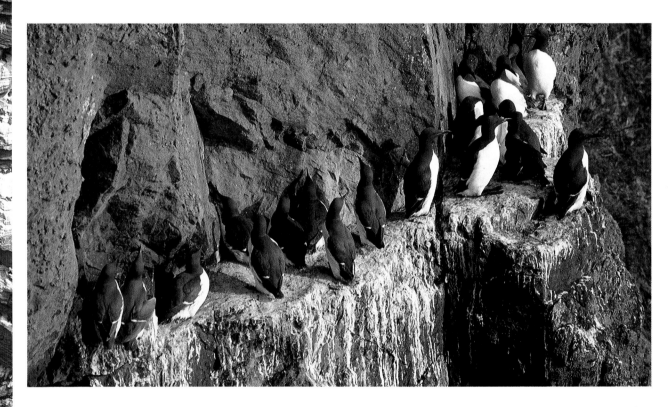

A typical choice of nest location for guillemots
is on long narrow ledges. The eggs are laid
on the bare rock and are shaped so that they
roll around in a circle, which prevents them
tumbling over the edge of the cliff.

The razorbill is a member of the auk family of birds, which includes guillemots and puffins. All the auks stand in a rather upright fashion because they are designed for life at sea rather than on land. The legs are placed far back on the body to give maximum propulsion in the water, but it causes the birds to look awkward on land. Their wings are a compromise between an efficient underwater paddle and a method of flight. As a result the flight of most auks can look almost panic-stricken and rather uncontrolled.

The auk family of the northern hemisphere reflects the penguin family of the southern hemisphere. However, they are not related to each other.

The short stubby wings are designed for underwater swimming. However, the razorbills are still able to fly.

36

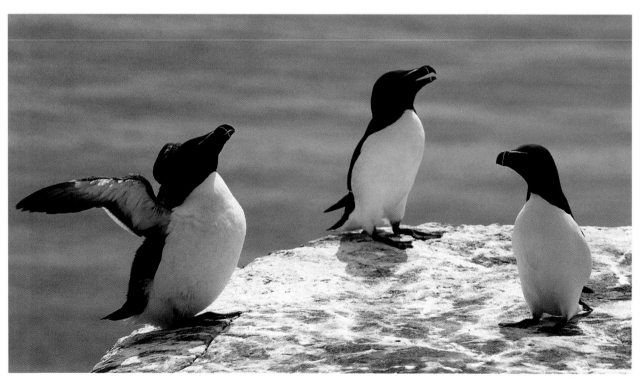

Almost three quarters of the world
population of razorbills breed around the
coast of Britain and Ireland. They choose a
variety of sea-cliff locations to nest but like
to be more hidden and secluded than the
guillemots which share the cliff.

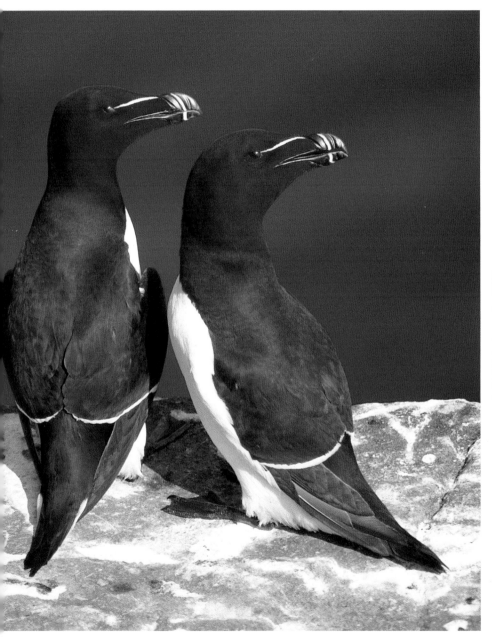

The razorbill's back is glossy black, which
contrasts with the pristine white eye and
beak stripe.

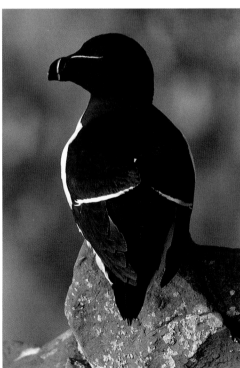

Puffins are often thought of as comical little birds of the cliffs but this does not reflect their true character. Puffins are sea birds and everything about them is designed for an ocean-going existence. Underwater they are fast and agile in pursuit of fish, and remain out of sight of land for eight months of the year. Young puffins will not return to the colony for three years and remain out at sea all that time.

The vastness of the north Atlantic provides all that puffins require, except that they cannot lay their eggs on the sea.

38

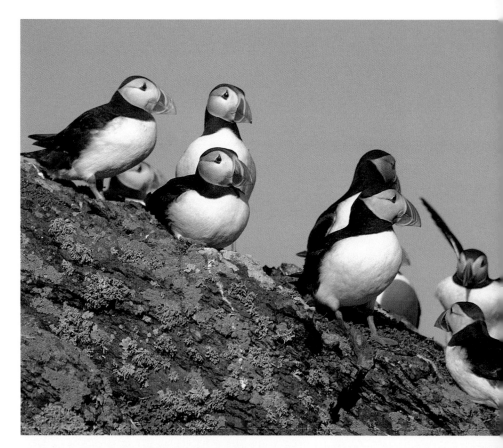

During the nesting season puffins are very sociable birds and often rest together in little 'clubs' on an outcrop of rock.

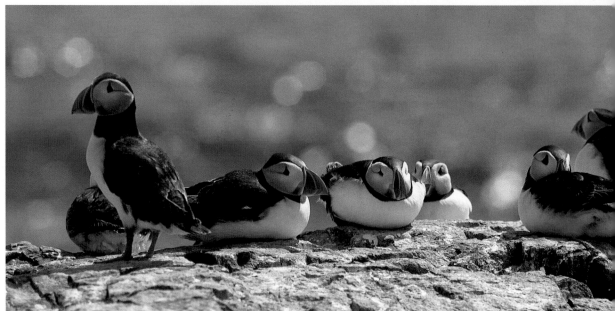

A little group of puffins rests on a rocky outcrop. Others will continue to join them as the evening progresses.

Its beak packed to capacity with fish, a puffin returns to the colony. Its chick will be waiting in the security of an underground burrow.

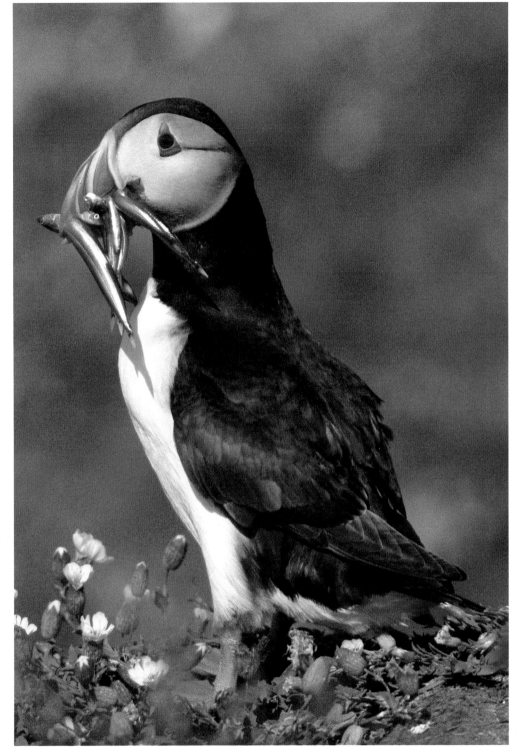

For most of their life on the ocean puffins are independent birds. However, during the breeding season they become extremely sociable. In the breeding colony they have learned to rely upon each other and relate to one another. They will continually circle around the cliffs, assuming it is not safe to settle if no other puffins have landed. Once one lands, however, others soon flutter down to join it. Although puffins occasionally fight, the colony is a peaceful place because of the way they relate to one another. They are able to convey their aggression, submissiveness, dominance and so on in the way they behave.

40

The best time to watch puffins is at the end of June or the beginning of July. All the adults are regularly visiting the colony to bring a supply of fish to their chicks underground. Numbers are also swollen to capacity by the sub-adults that hang around the colony. During the evenings, as the sun is falling in the sky, most of the puffins are resting on land. It is not until the sun finally sets that they fly out to sea where they roost for the night.

Puffins return from feeding expeditions on the ocean to rest in the colony, especially during the evenings. Encouraged by the presence of the adults, sub-adult birds that have not begun breeding join the colony during May. They learn to become part of the colony and are inquisitive enough to inspect the fish brought in by an adult. They will breed the following season.

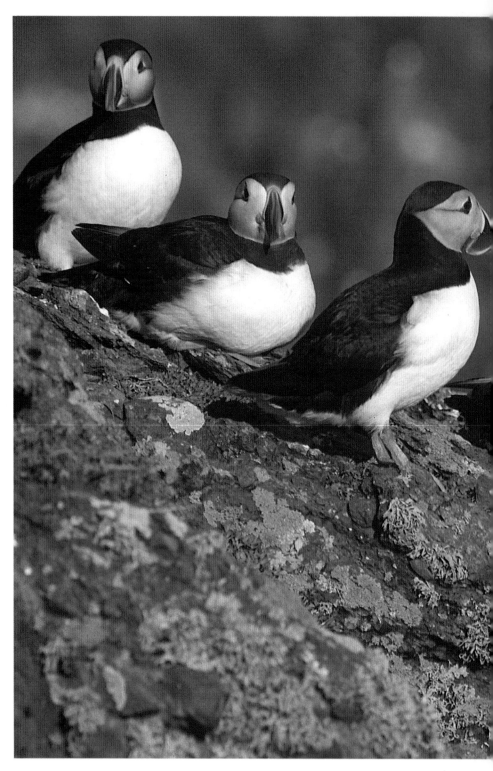

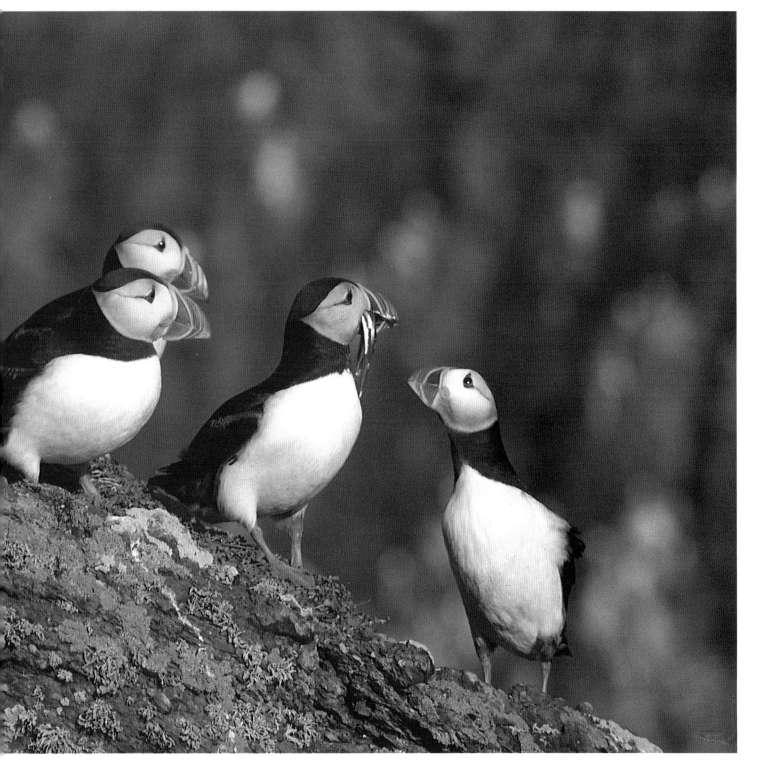

What a difference a day makes . . . Wet and windy weather can spell disaster for birds that are nesting. Many insects have little time to feed and reproduce, and plants need to be pollinated to ensure the next generation. As humans we complain about the weather, or enjoy the changes in it, but it affects the wildlife of the coast to a much greater extent.

For several days a secluded cove is lashed by wind and driving rain.

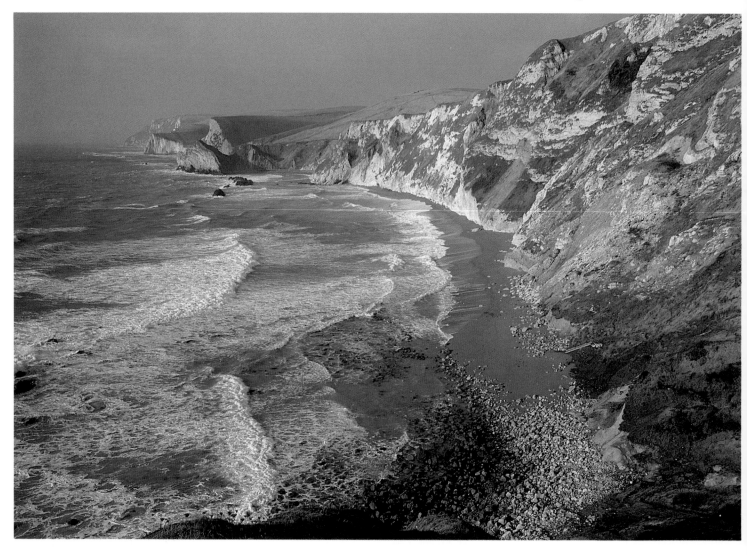

Within twenty-four hours the whole atmosphere can change from a foaming stormy sea to a sea of blue calm. Dark clouds are banished and replaced with a clear blue sky so that the sunshine can highlight the white chalk of the cliffs once again.

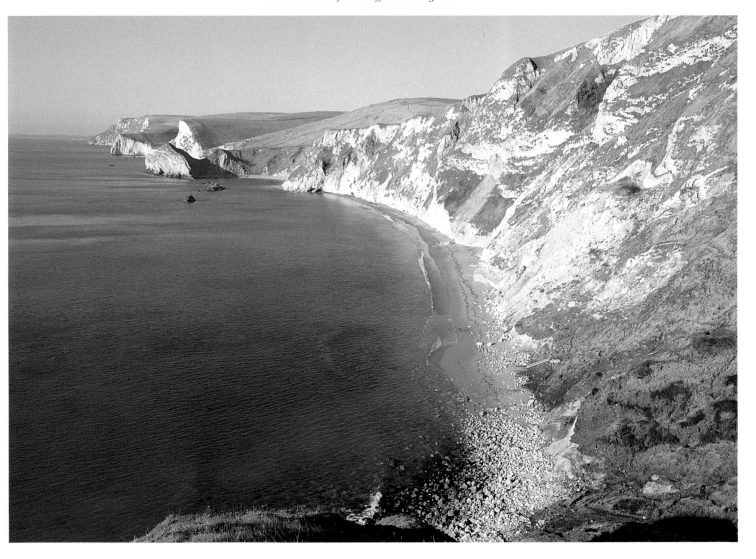

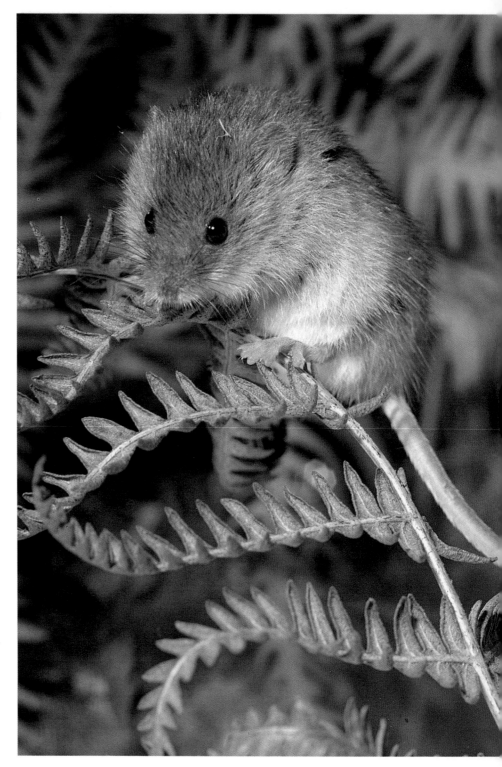

During late summer and autumn, a harvest of wild fruits ripens on the bushes and shrubs along the cliffs and in the dunes. Some plants thrive only around the coast, but others take advantage of the uncultivated soil of the cliff tops. This provides a good supply of food for a variety of birds that arrive in the British Isles to overwinter in our milder climate.

Clearly the plants rely upon birds to distribute the seeds. They digest the soft outer layer and pass the seeds through, to be delivered a mile or two away — with a useful dose of fertilizer!

44

Harvest mice are not slow to take advantage of the wealth of berries. Being the smallest British rodent and therefore the lightest (6–8g) the mouse is able to clamber along the most slender stems to select a particular berry. Its nose is blunt and rounded compared to other mice and its ears and eyes smaller. Together with its size, this gives the impression of a delicate little creature.

Sea-buckthorn is a thorny deciduous shrub that is particularly associated with sandy soils, although it is also found on cliff tops. Because sea-buckthorn creates dense thickets it is often used as a favourite roosting site by birds.

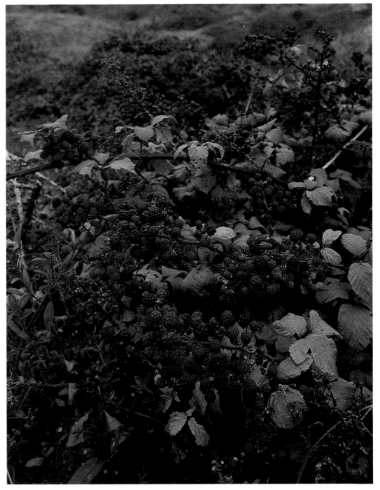

Blackberries are part of a wild harvest that we enjoy – but not only humans. Wild fruits are a vital food supply to many creatures, including both birds and mammals.

Eiders spend most of their lives in tidal waters and are thoroughly marine birds. They feed on a variety of shellfish, especially mussels, which can be ripped from their beds and crushed with the eider's powerful beak. They are the largest ducks found around our coast and in general they are associated with the colder waters of the north.

The eider drake's plumage is a striking pattern of black and white with subtle hints of pink on its chest and green on its neck. The most rewarding time to watch eiders is in the late winter and early spring when courtship begins. The evocative call carries over the waves — a gentle, low, crooning sound. This accompanies a great deal of bobbing of heads and weaving about in the water as the drakes attempt to catch the eye of the drab ducks.

Eider are wild ducks that bring thoughts of wild places to mind, but at a breeding location they can often be surprisingly tame and confiding.

When it is on the surface of the water the eider does not look like a bird that is capable of diving beneath the waves. However, it is able to dive powerfully and can even swim underwater among strong surf. It uses its wings as well as strong feet to power its way through the water.

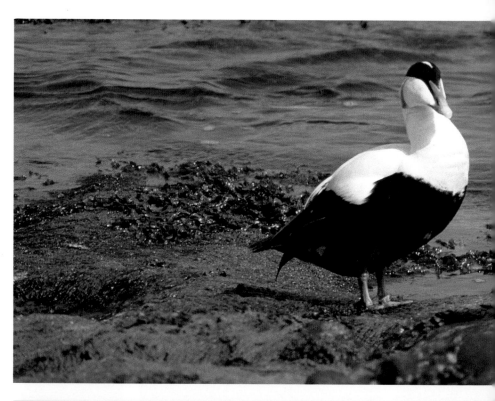

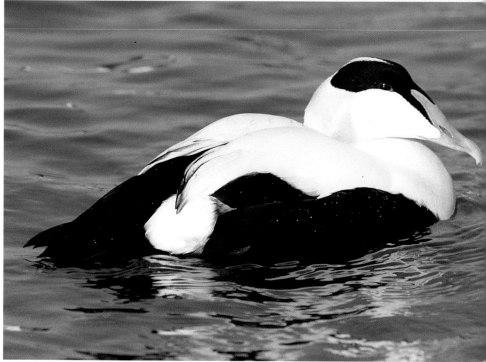

46

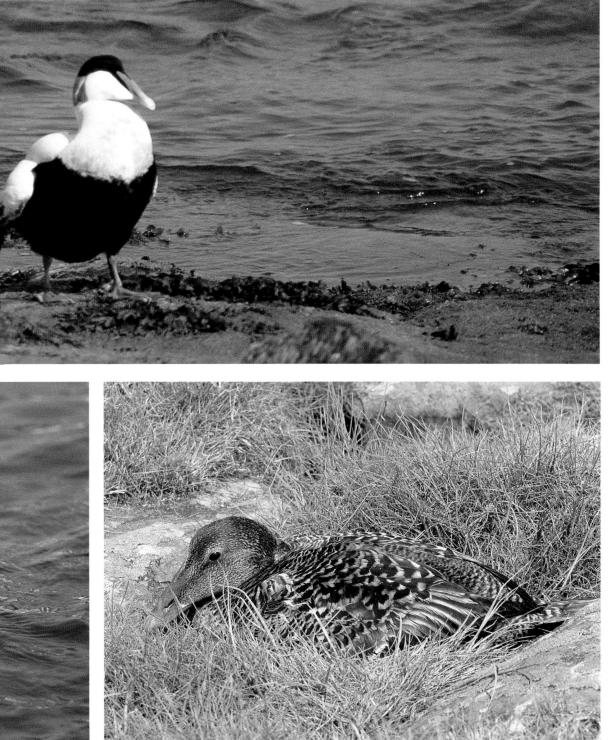

Eider drakes play no part in incubation duties and while the ducks are sitting on eggs little groups of drakes can been seen feeding on the tide-line.

Eider ducks sit tightly on their eggs, totally reliant upon their camouflage. As soon as the ducklings hatch they are immediately led to the sea.

There is often an exciting variety of plants to be discovered on a coastal walk. Some of these plants are essentially maritime, whilst others can also be found further inland. The conditions on the cliff top are harsh and any plant that is to survive there needs to be persistent and hardy.

It is the constant sea breeze and strong winds that determine the cliff-top vegetation. The unrelenting wind very rapidly dries out the soil so, to overcome the problem, many plants have deep, strong root systems. It is difficult for seedlings to become established and they suffer most from drought, until their roots are well developed. In spite of these problems, throughout the spring and summer months the cliff tops are decorated with a profusion of flowering plants.

Some plants seem to have most unappealing names — and common scurvy-grass is one such unfortunate plant.

48

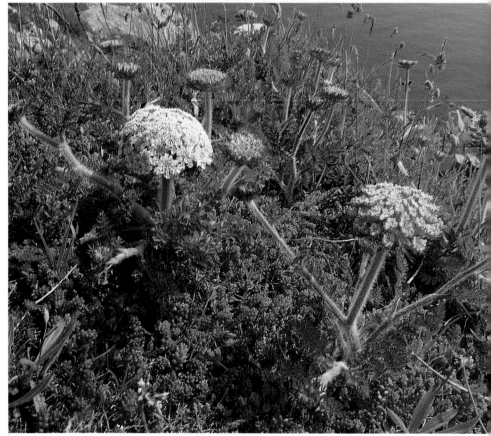

Although wild carrot can be found on many roadsides and other grassy places, it favours a cliff-top habitat.

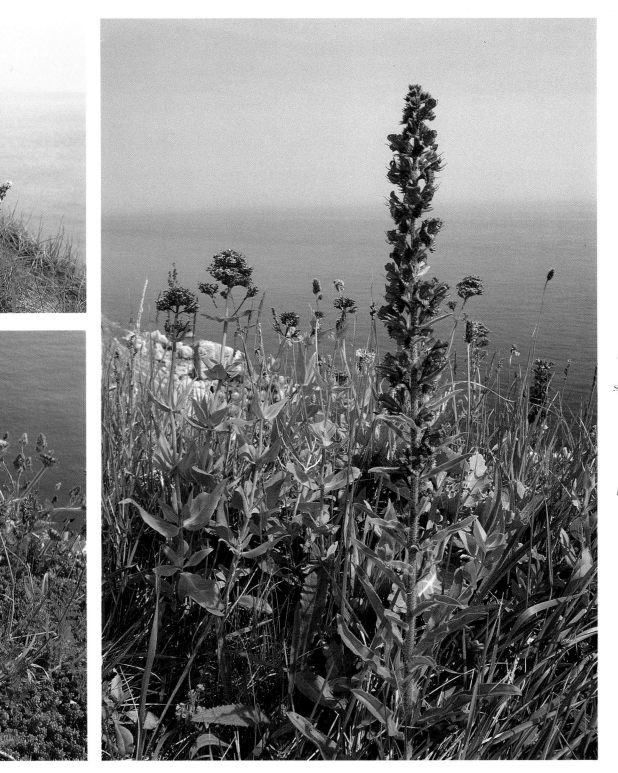

Viper's bugloss produces a striking blue/purple flower spike and is a native wild flower of the British Isles. Red valerian, on the other hand, is a plant that has become naturalized into the wild from garden escapes.

49

Thrift and sea campion are two species of plant that are great specialists of the wild coast. Most cliffs have a few clumps of these attractive plants but in some locations the white of the sea campion can stretch away far in front of you like a huge white sheet of flowers. Then the white of the campion may be over-taken by the purple of thrift that tumbles down into the blue sea. Not only is it a beautiful sight, but it is equally delightful to smell, and it is rare to find such a display of wild flowers growing out in the open, except on the cliff top.

Both species grow in tight clumps or tussocks. This helps to conserve the moisture in the soil by shading the soil from the direct sun and also by preventing the drying wind reaching the soil.

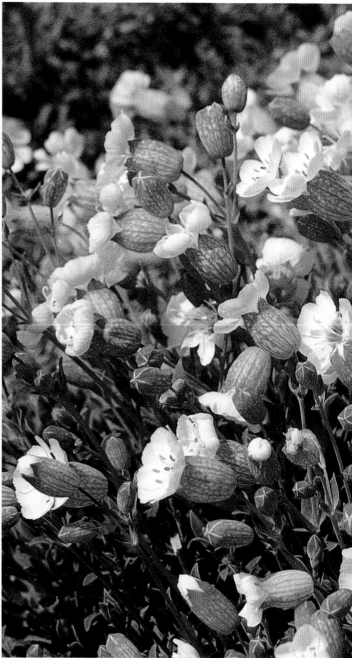

Delicate white flowers of sea campion are constantly trembling in the breeze.

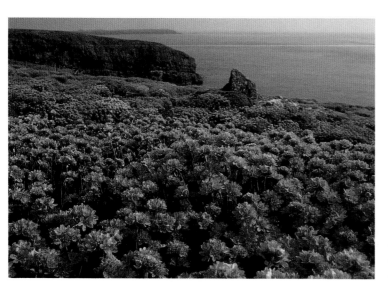

A purple carpet of thrift stretches down to the very edge of the cliff.

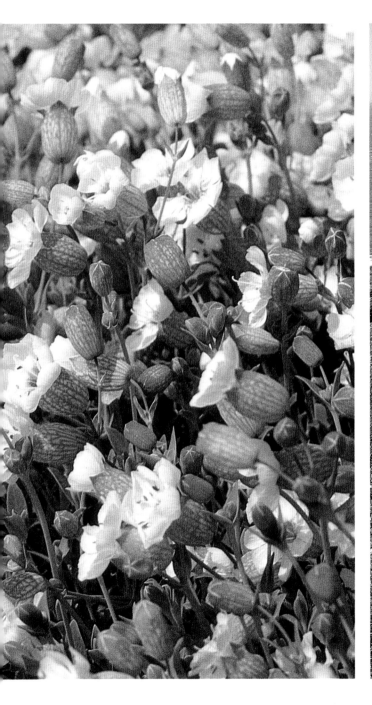

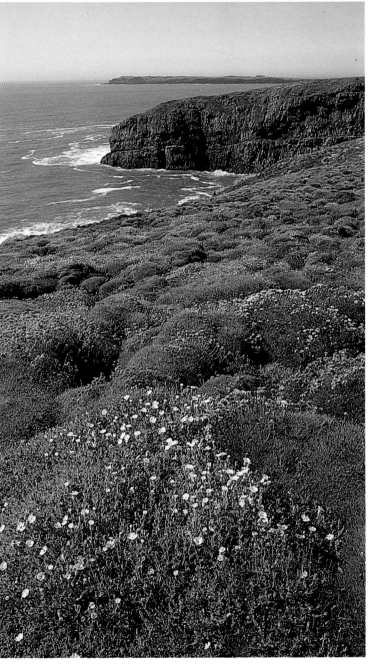

The tight clumps of sea campion and thrift stop the soil from drying out, helping to prevent erosion.

The common seal is the smaller of the two British seals and despite its name is far less numerous than the grey seal. Although the common seal is smaller than the grey, they can still be difficult to tell apart. The common seal has a more cat-like shape to its head and its nostrils are in V-shaped formation. The grey seal has a longer, more horse-like head and its nostrils are more parallel.

The common seal favours a habitat of sheltered parts of the coast — sea lochs and estuaries are a typical choice. They feed mainly on fish but will also eat a variety of shellfish, squid and crabs.

During June or July the females haul out at low tide onto a sandy bank or exposed rock. It is here that they give birth and, as the tide rises, the newly-born pup is able to take to the water along with its mother. It seems remarkable that only a few hours after a pup leaves the warmth of its mother's womb it takes to the cold water of a Scottish loch.

52

Many different species of seaweed are revealed as the tide falls. At least four species are visible in this photograph — thongweed, carragheen, toothed wrack and forest kelp. The limp plants are only a poor reflection of the underwater world that the seal enjoys.

The falling tide reveals a landscape of seaweed-covered rocks. Only the ridges that are most exposed to the pounding of the surf are not colonized by the tenacious seaweeds.

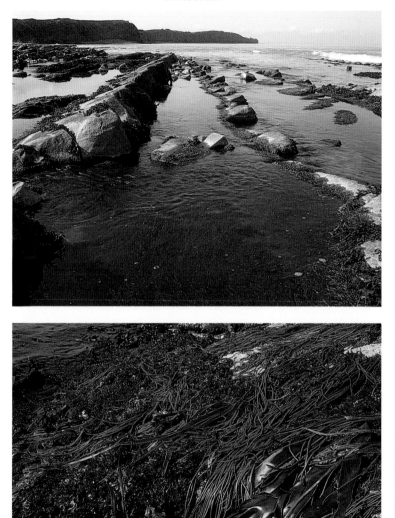

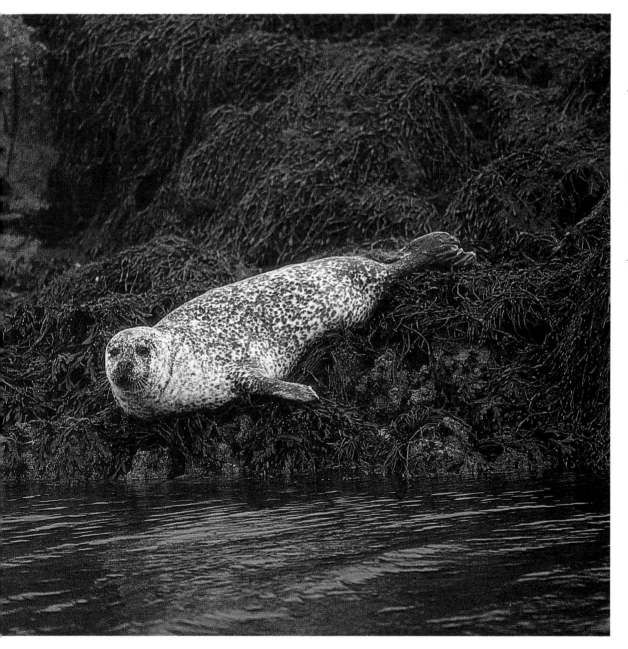

As the tide retreats, common seals regularly haul out onto the seaweed-covered rocks. They choose locations that enable them to escape into deep water should any danger threaten. As the sea rises they remain on the rocks until finally the tide floats them clear. They swim and feed until the tide falls once again.

53

A visit to a tern colony during the height of the breeding season is not for the faint-hearted. Terns fly directly at you from all directions, even striking you on the head, sometimes drawing blood.

Common and arctic terns are not easy to tell apart because in most respects they look very similar. The arctic tern has shorter legs, but the main feature during the summer months is that the arctic tern has an all red beak whilst the common tern has a black tip to its red beak.

54

To catch a fish a tern drops out of the sky and plunges head first into the water. Fish are used as a courtship gift between the pair but this arctic tern has brought a fish to land to feed its growing chicks.

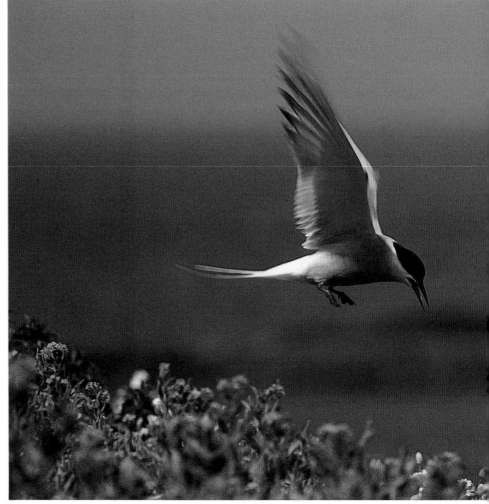

When watching a tern in flight it is easy to understand why they are sometimes referred to as swallows of the sea. They have a graceful, effortless flight that takes them not only on fishing expeditions, but also half-way around the world on migration. Arctic terns travel furthest, often spending the British winter in the Antarctic and returning to breed the following spring.

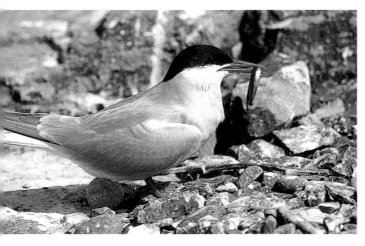

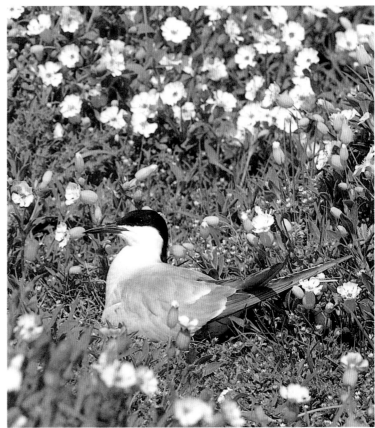

Both the common and arctic terns' nests are very simple; little more than a few twigs among the vegetation. This common tern has chosen to nest surrounded by sea campion.

There are many wild islands around the coast and each of them seems to have a character of its own. Just off the south-west tip of Wales lies Skomer Island, and one of its greatest features can be observed during May. It is as if the whole island becomes a huge wild garden, and the greatest attraction is the bluebells. In some areas they stretch from the centre to the edge of the island, and in among the bluebells live countless rabbits and Skomer voles.

Most islands are fascinating places where a complete web of life can be observed within the confines of the island — like a miniature world surrounded by ocean. The undisturbed soil produces a profusion of plants that are fertilized by bird droppings. The plants provide food for insects as well as small mammals. Birds feed on insects — birds feed on birds.

The absence of mammalian predators on most islands means that birds are at the top of the food chain, and so they nest in huge numbers. Screaming calls of gulls mingle with piping cries from oystercatchers and curlews so that the character of an island becomes its sounds as well as its sights.

Bluebells cannot tolerate too much sunlight, so they are usually found growing under trees where the leaf canopy shades them from the sun. On Skomer there are no trees, but once the bluebells have finished flowering, bracken quickly grows up and its fronds protect the delicate bluebell leaves from the sun's harmful rays.

Several pairs of short-eared owls nest on the island, where they feed on voles and other rodents. They are much more active during the daylight than other species of owls and can often be watched quartering the ground in bright sunshine or chasing each other in mock aerial battles.

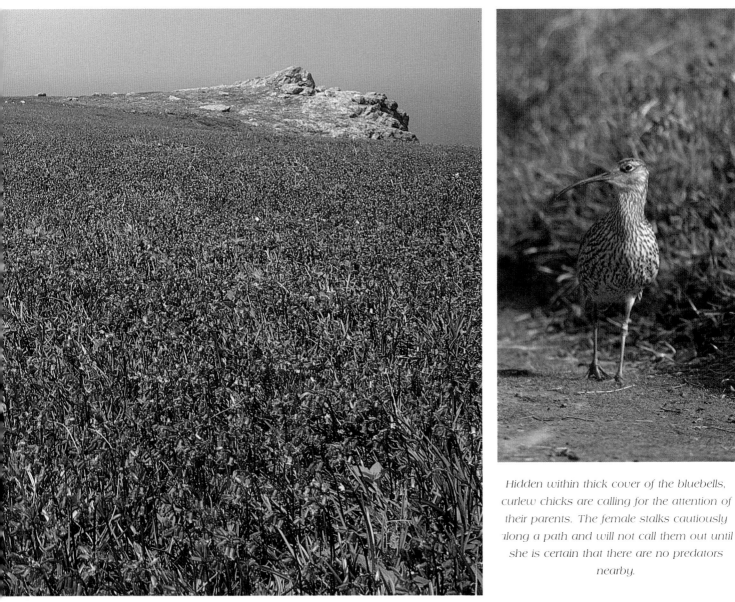

Hidden within thick cover of the bluebells, curlew chicks are calling for the attention of their parents. The female stalks cautiously along a path and will not call them out until she is certain that there are no predators nearby.

A tide line of washed stone is one of the barren parts of the coastline. The gaps between the smooth rocks are too large to retain water and so plant life cannot get established. Worms cannot burrow between the boulders (as they can in sand) and the loose stones are tossed about too much during a storm to provide a home for winkles, whelks or crabs.

Any life that exists here scavenges on what each tide throws into the boulders. Rotting seaweed or half a dead crab is all that is on offer but that is sufficient for many small shore creatures, such as springtails or sandhoppers.

58

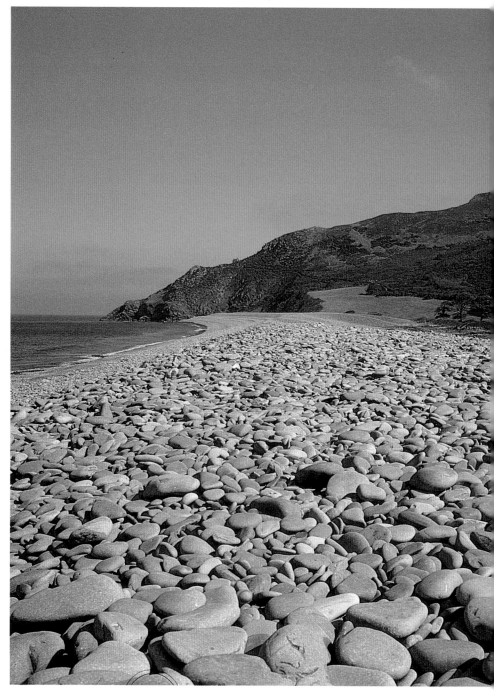

Washed by the tide and bleached by the sun, a great bank of smooth stones separates the sea from the land.

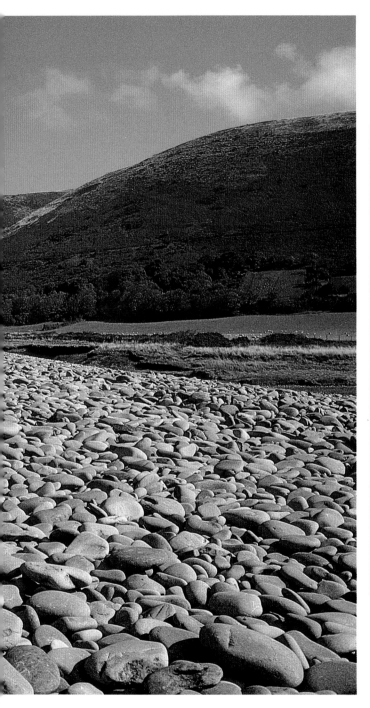

Jackdaws are quick to explore every habitat in their search for food. This member of the crow family is equally at home in the woods as it is scavenging on a boulder-strewn beach.

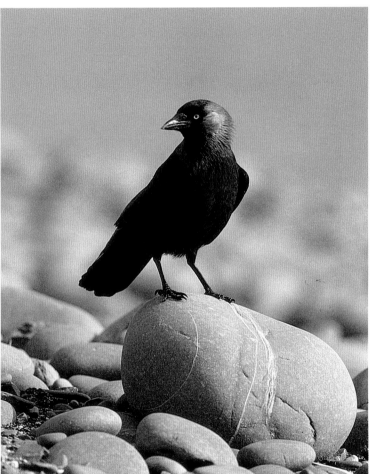

It has been calculated that 70 per cent of the world population of gannets breed around the British coast, and a gannetry during the breeding season is a most spectacular place to visit. These huge birds with their two metre wingspan constantly drift just overhead as you sit quietly on the edge of the colony.

In the last century the world population of gannets has trebled. This is a remarkable achievement, bearing in mind that a pair of gannets can only raise one chick each year and that they do not begin breeding until they are five years old.

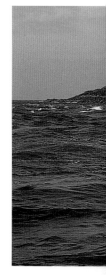

The density of gannets is so great that it gives the impression of snow, even when viewed from several miles away. The huge birds are constantly flying to and from the island on feeding expeditions.

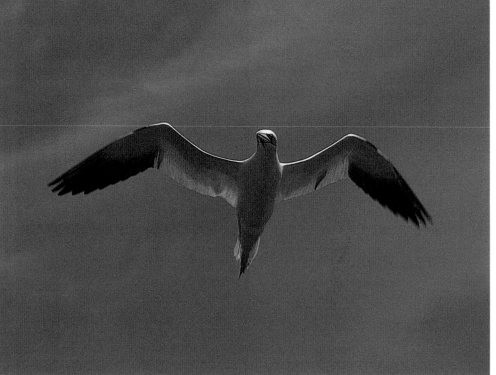

Gannets fly above the waves on the look-out and then, like great white arrows, they plunge into the sea to grab a fish. Some dives may be from as high as thirty metres.

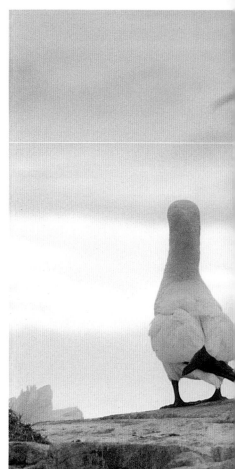

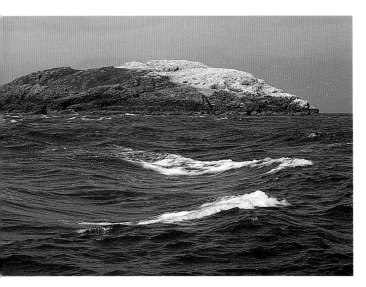

OVER THE PAGE
Approaching the colony more closely, the sheet of white that seems to cover the island can be identified as thousands of individual white dots — each one a gannet. The nests are evenly spaced throughout the colony, each pair having a territory that is governed by length of neck and powerful beak while sitting on the nest.

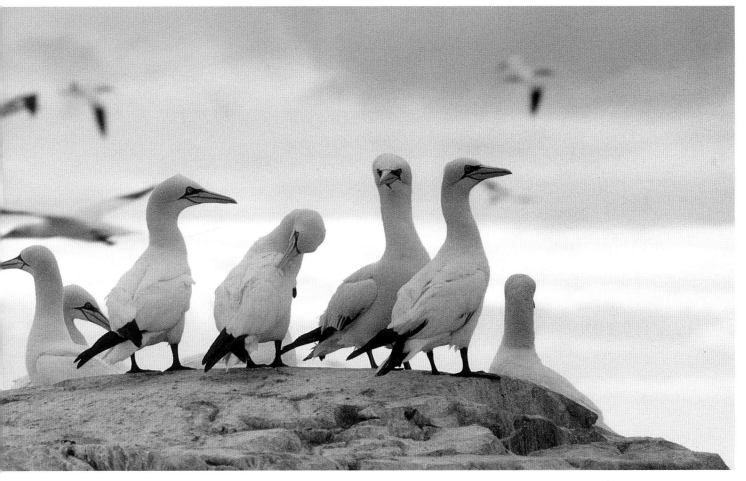

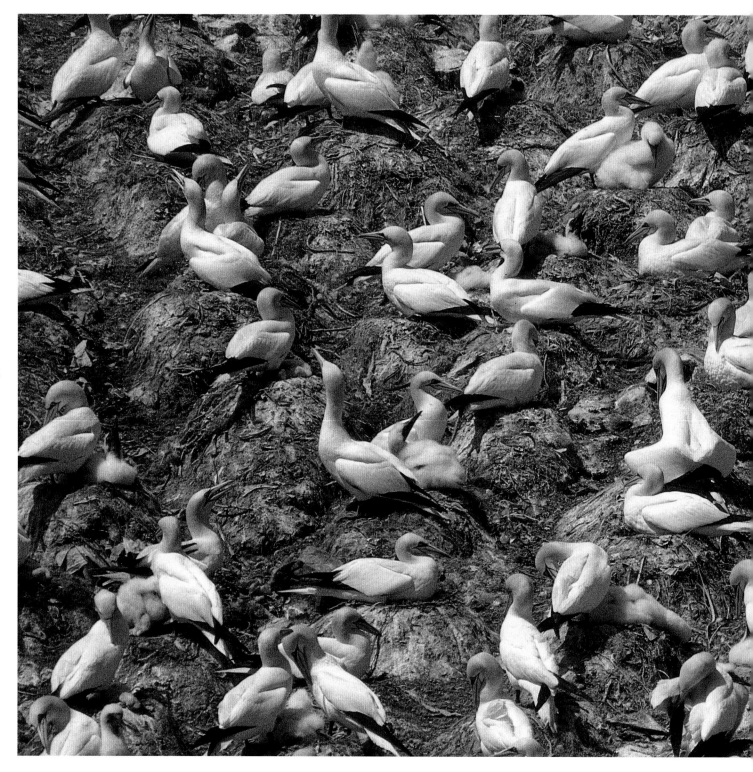

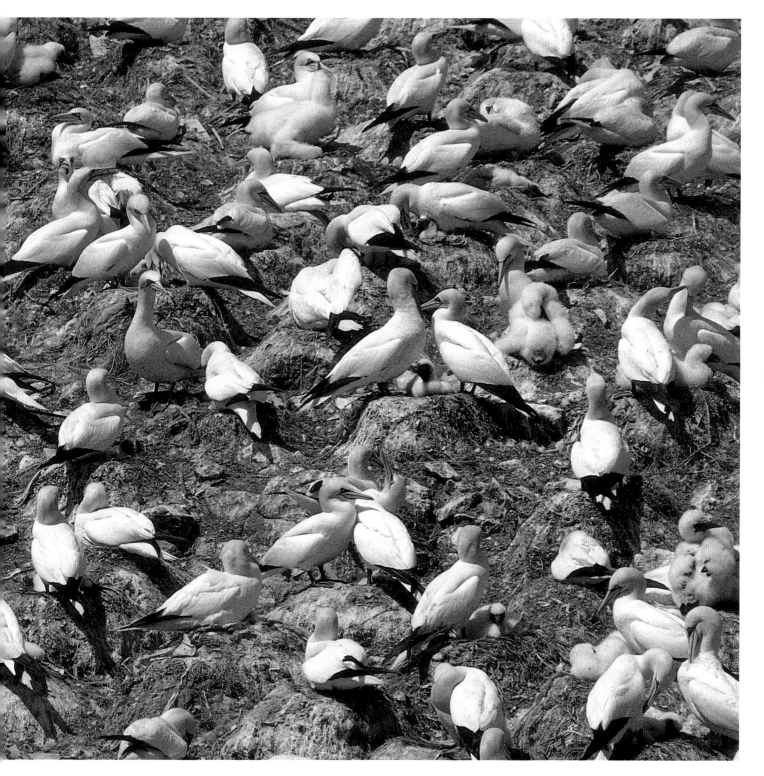

Each tide leaves its unique signature in the sand. As the water rises, the waves lap across the sand erasing the patterns created by the previous tide. Each tide cleanses the beach and washes away blemishes that indicate activity on the beach at low water. Dependant upon its humour, whether stormy or calm, it leaves an impression of its mood behind.

64

As a little brook trickles across the smooth sand it paints its own image: a miniature estuary that reflects the huge sand-bars and deep channels found where mighty rivers meet the ocean.

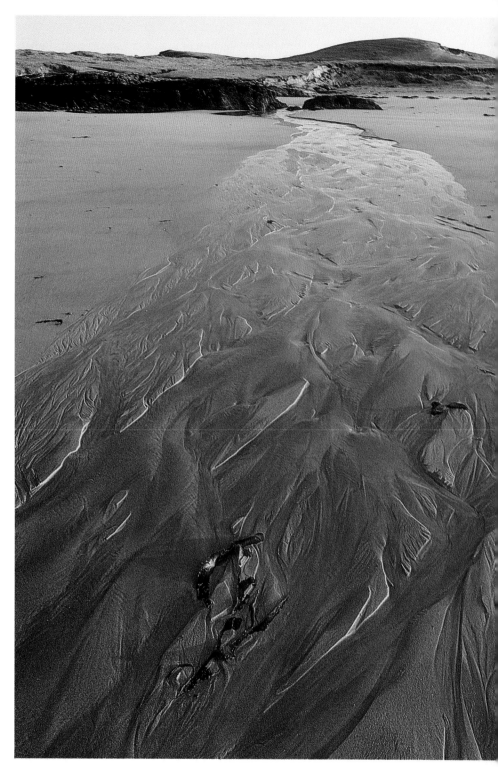

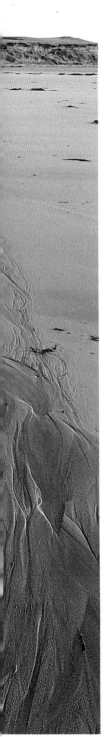

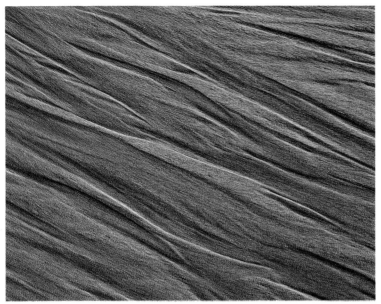

Sand that has been dried by the sea breeze retains the pattern of the tide; and the wind adds its own creative sculpture.

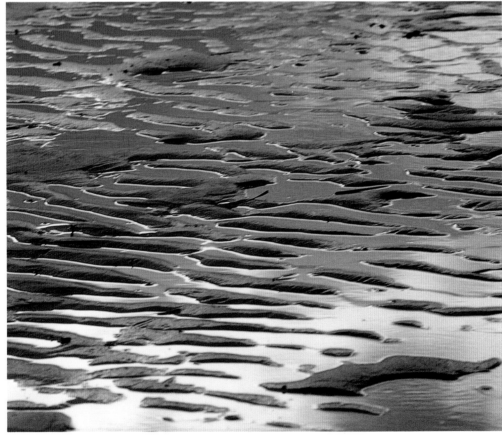

Damp sand displays the ridges and gullies from the gentle washing of the last tide.

Dotted all around the British coast are hundreds of small islands. Many of them are virtually undisturbed by humans, except by those who enjoy the wildlife and atmosphere of these remote locations.

One such island is Handa which is situated off the north-west corner of Scotland. The island is like a great wedge rising out of the sea. At the lower end, beautiful sandy beaches are washed by the tide, and few human footprints ruffle the smooth sand. The island steadily rises until huge cliffs plunge vertically down to the sea 120 metres below. These massive cliffs provide nesting sites for over 100,000 breeding birds, many of which are guillemots.

On most of these islands it is possible to find signs of past human habitation and agriculture. Today this is uneconomical and many of them have become splendid nature reserves managed for wildlife.

To arrive at the towering cliffs from the landward side is a breathtaking experience. The unexpected height and the smell of guano takes one's breath away, in more ways than one! With so many sea birds breeding on the cliffs it is hardly surprising that the dark rock becomes whitewashed with guano.

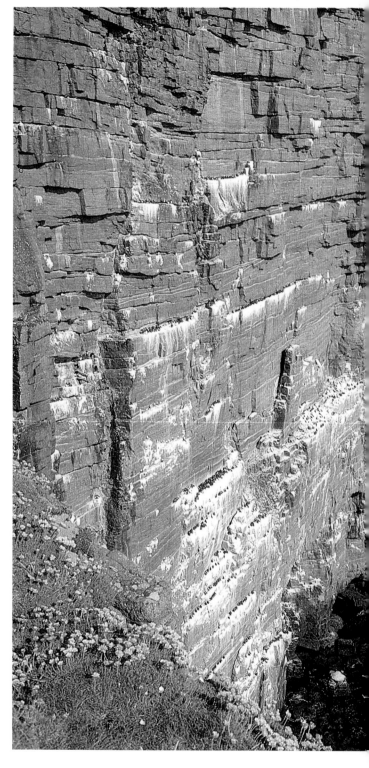

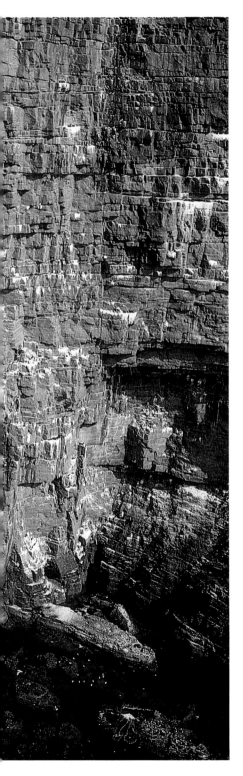

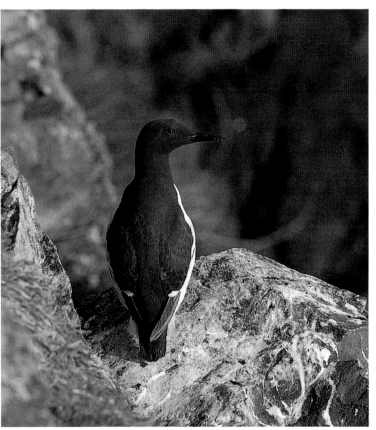

About 25,000 pairs of guillemots raise their young on the cliffs of Handa.

It is difficult to imagine that a sandy beach is made out of solid rock: countless millions of minute particles of rock and shells that have been eroded away by endless years of washing by the tide. We are unaware of most of the invertebrate creatures that live within the sand. When the tide is out the beach is revealed, not only to our eyes, but also to the eyes of birds that would feed upon the thousands of worms, crustaceans and molluscs. Therefore they adopt a strategy of burying themselves in the sand at low tide, to hide from prying eyes as well as from the heat of the sun and drying wind. All these creatures feed during high water, either on plankton carried in the current or by filtering the sand.

Nevertheless, many wading birds search the beach for the life that is hidden in the sand.

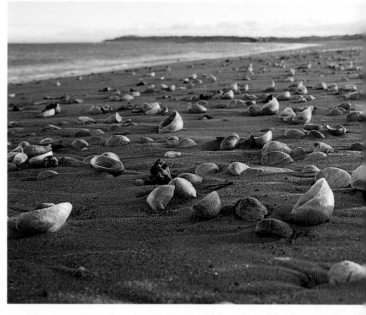

68

A shore crab scuttles for cover at the slightest sign of danger. They really live below the low-tide line, but are often found on the beach where they are happy to scavenge any edible fragments they can find.

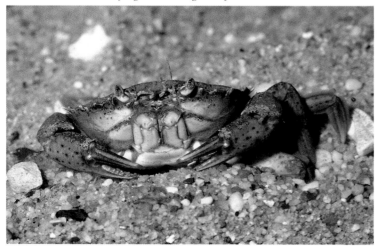

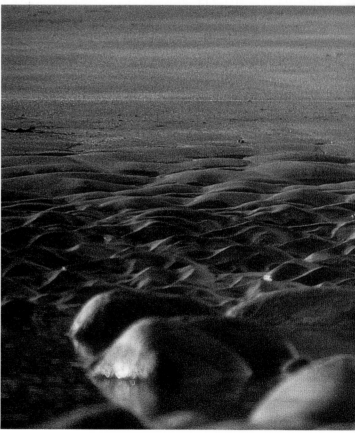

Shells of slipper limpets and cockles litter the beach, but in time they will be broken down into minute particles, when they become part of the sand.

A lone golden plover wanders slowly along the beach, watching for any sign of life that has not hidden itself beneath the sand.

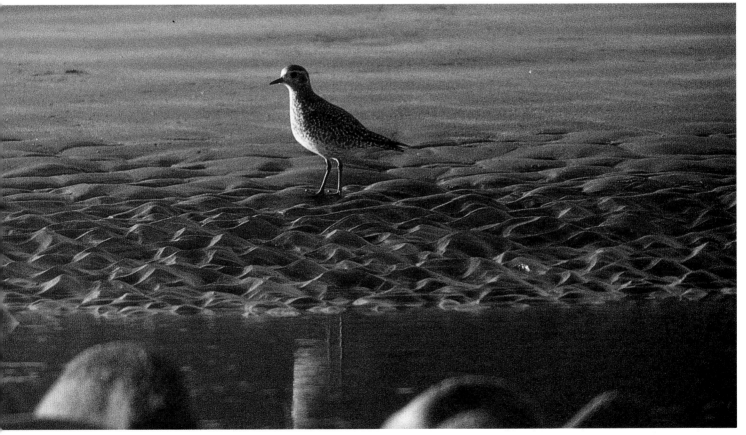

An indication of the productivity of the shore-line is the countless thousands of wading birds, of many different species, that feed there. Each wading bird has its own technique for feeding, which helps to reduce competition. Many feed from the mud found in the estuaries because this is probably the most productive part of the coast. Some delicately pick creatures from the surface, while others probe into the mud to feel creatures that are hidden from view. The design of the beak indicates the bird's feeding method because its length determines how deep they are able to probe.

70

Although some waders choose to feed alone, the majority work together in great flocks. When numbers are at their highest, during winter, hundreds may take to the air to form a moving cloud of birds that fly in unison, creating an aerobatic display.

Many species of waders, such as turnstones, move north in the spring and breed in the colder climate of the Arctic. Curlews are largely resident. Whilst some dunlin decide to migrate, others remain to breed, especially in the north.

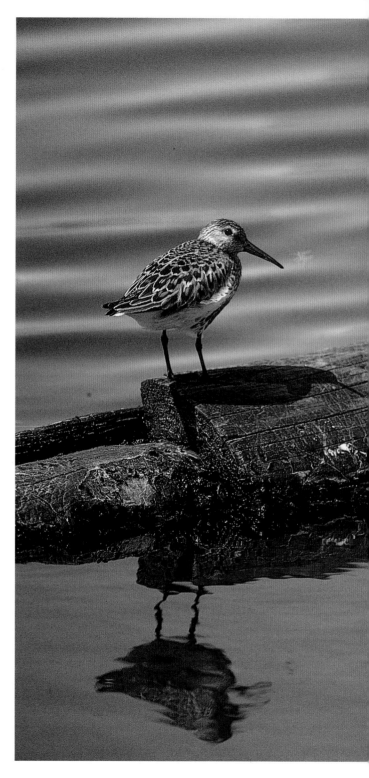

During winter the dunlin's plumage is a rather dull, grey-brown with a pale belly. In the breeding season it develops a black belly and its back becomes mottled, rufous-brown. It is generally the most common wading bird to be observed.

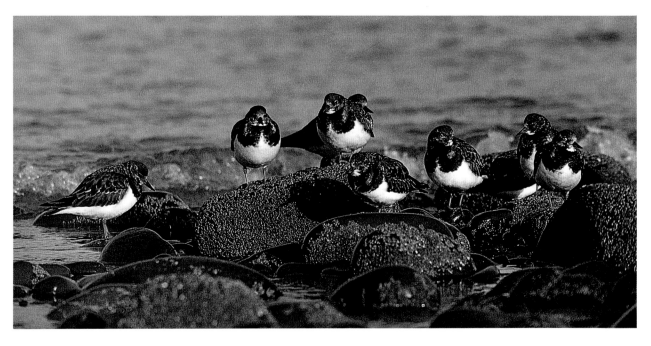

Turnstones have developed a feeding method of their own. Their
short beaks and stocky build enable them to turn aside stones,
seaweed and other debris on the beach. This reveals sand-hoppers
and other crustaceans upon which they feed. They will also take
small molluscs and worms and even feed upon carrion.

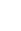

Some sea bird colonies are inaccessible to all but the most adventurous naturalist. The Farne Islands, however, have been made easily accessible by regular boat trips during the summer months. Although large numbers of people visit two of the islands each day, they still remain wild and exciting. The opportunity to see (and smell) a thriving sea bird colony first hand is not to be missed, and to wander along the paths, only a few metres from nesting birds, is a thrilling experience. Grey seals are usually seen during the boat trip as they haul out onto the half-submerged rocks to rest.

There are some thirty islands in the group and most are nature reserves, managed by the National Trust.

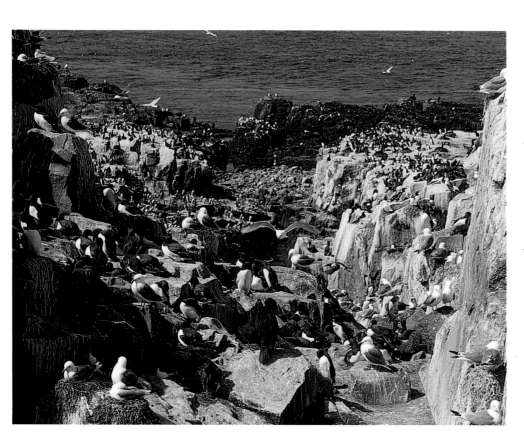

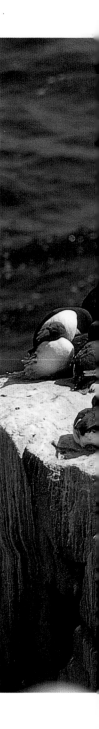

It seems as if every square metre of the islands is taken over by birds. Kittiwake, guillemot, razorbill, puffin, shag, eider, fulmar, cormorant, oystercatcher and four species of terns — to mention the most common — the list of birds is impressive.

*Guillemots cram
together to nest on
one of the island
stacks.*

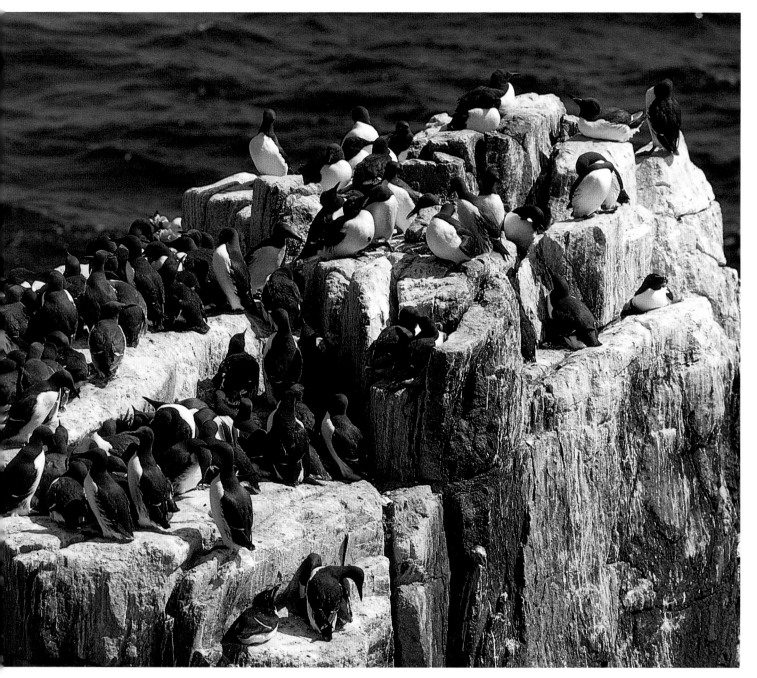

etween the tides are revealed rock pools full of life. They give the opportunity to get a taste of the strange life that is to be found beneath the ocean's waves. However, a rock pool is not really like the sea. It is a habitat of extremes and both plant and animal life there is designed to cope with the constant change.

The temperature of the sea changes very slowly but a rock pool contains only a comparatively small volume of water which warms very quickly on a hot summer's day. A pool may feel deliciously warm to the touch one moment, then, as a tide returns, it is suddenly flooded with cold water once again.

Seaweeds absorb carbon dioxide and release oxygen into the water, but as with other plants, this can only take place in the daylight as a result of photosynthesis using sunlight. During the hours of darkness the reverse takes place and oxygen is removed from the water by the seaweeds. So, dependent on whether the tide is out during the day or night, the level of oxygen in the pool increases or decreases. Animal life always requires oxygen and gives out carbon dioxide, so there are times, especially at night, when a pool may be starved of oxygen.

The sea fills a pool with salt water but a heavy rain storm may dilute the solution significantly. On the other hand, water evaporates from a pool in hot weather, leaving a more concentrated solution of salt behind. A sudden change takes place again as the tide returns.

All life within a rock pool has to be able to live with this constant change of temperature, oxygen and salinity.

74

Green seaweeds cling to the worn rock, while in each pool animal life thrives.

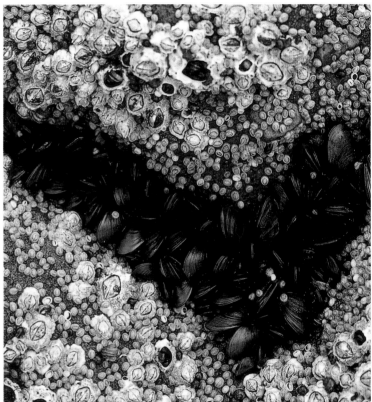

It is difficult to imagine that
barnacles and mussels are living,
growing creatures. But when the
sea washes over them the black,
shiny mussels will open to filter the
water for nutrients and each
barnacle will extend feathery 'legs'
to trap food particles in the water.

Not all plants found near the sea are specific to a coastal habitat. The undisturbed ground provides the opportunity for many species of plants that can often be found further inland to thrive.

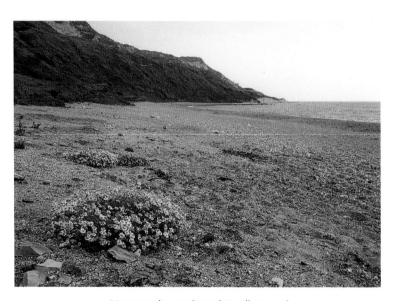

Mayweeds are found in all sort of locations from agricultural land to woodland. This particular plant has established itself on a beach and is a sub-species that has adapted for survival close to the sea. Appropriately it is known as sea mayweed.

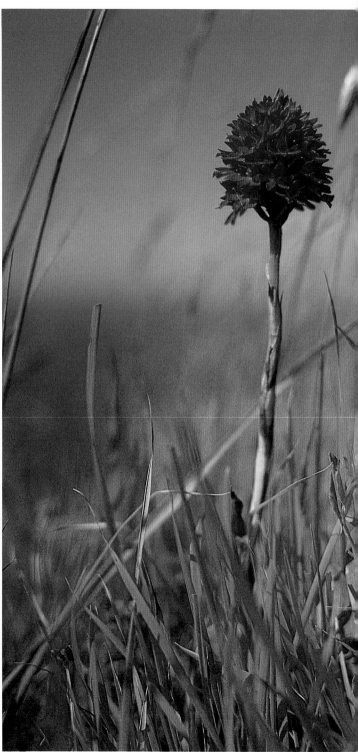

Pyramidal orchids are usually found in dry grassland and mainly on chalk soil. That is exactly the location of this specimen — it just happens to overlook the sea.

Delicate harebells tremble in the sea breeze.

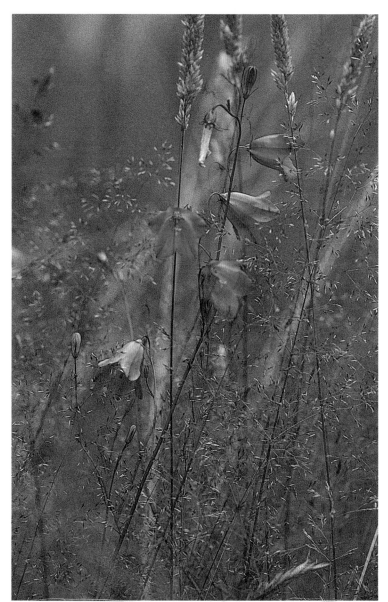

Birds that enjoy rough hillsides and open waste places find an ideal location on top of the cliffs. Scrubby vegetation, including bracken, brambles, heather, gorse and low-growing shrubs, provides good cover for nesting. There are also plenty of ideal look-out posts from which birds can sing their territorial songs.

In the spring, migratory birds that have just arrived often spend only a few days on the cliff tops, feeding and resting, before moving inland. But some remain on the cliffs to nest and raise their young.

Wheatears spend the winter in central Africa, and migrate to Europe to breed during the spring and summer. Although by no means exclusive to a coastal habitat, they can often be found nesting in crevices in cliffs or among boulders.

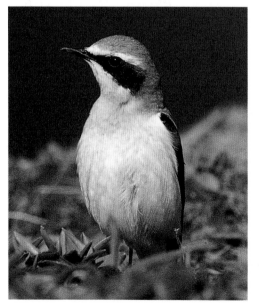

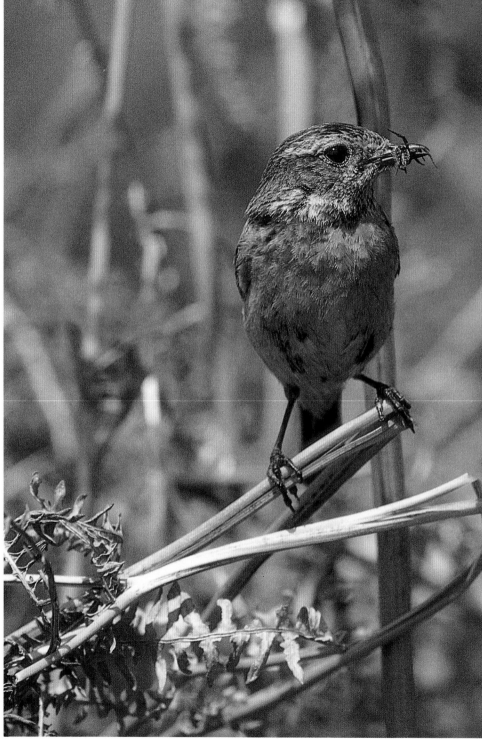

One of the most familiar plants found growing in acid soil is heather: also known as ling. During August or **September a purple haze may decorate the coast path and countless thousands of insects feed from the flowers.**

The stonechat's name derives from the call it performs whilst perched on a prominent twig — it sounds as if two pebbles are being tapped together. It is a resident bird, and so can be found throughout the year. During the spring the nest is hidden amongst heather or gorse and is always on the ground. An experienced pair of stonechats may raise several broods each year.

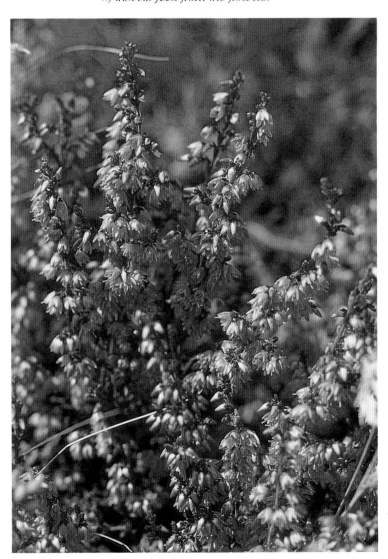

Two species of gulls that are very closely related are the herring gull and the lesser black-backed gull. Indeed, where they breed in close proximity to each other, it is possible to swap the herring gull's eggs with those of a lesser black-backed. As the chicks grow they will assume the identity of their foster parents, and in later years will even breed with the 'wrong' species. However, without this human interference the hybridization of these two gulls is most uncommon.

Understandably, their behaviour is almost identical. These are the gulls one would expect to find on seaside holidays, feeding in fishing harbours, scavenging rubbish, following boats and perched on roof tops.

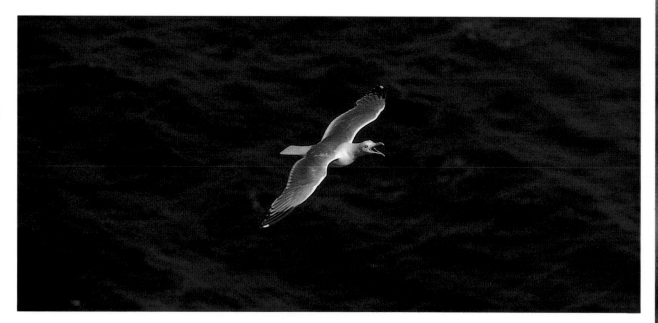

The raucous calls and wailing cries of a herring gull are as much part of the coast as is the sound of the waves.

80

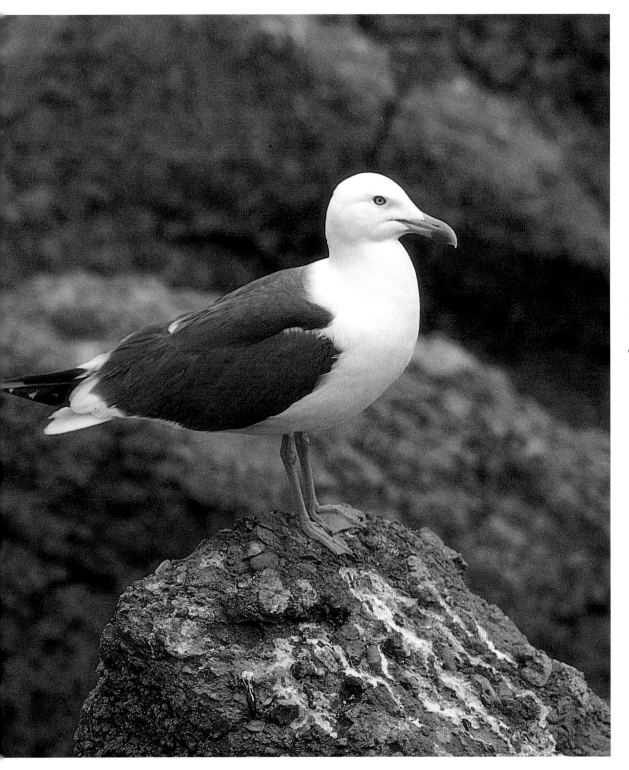

The dark grey
mantle of the lesser
black-backed gull is
the feature that
distinguishes it from
the herring gull.

Lichens

Lichens are a strange combination of algae and fungus, and are usually the first form of life to colonize bare rocks. All lichens are badly affected by pollution but where the air is clean they are very long-lived — they can even out-live trees. Few lichens have common names, so even the most familiar species are referred to by Latin names.

The clean air of the coast suits *Xanthoria parietina*, and rough boulders often become encrusted by this brightly coloured lichen.

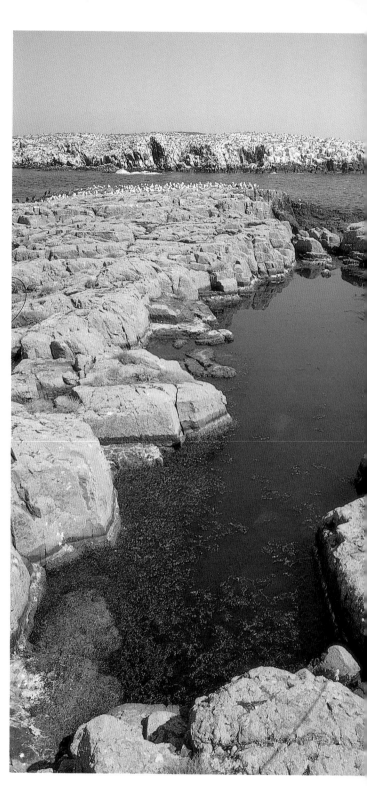

Xanthoria parietina is one of the most common lichens. It grows in a variety of locations including on trees, walls and bare rocks.

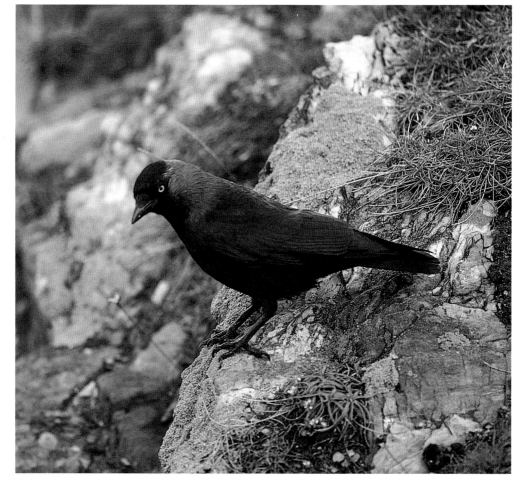

Jackdaws are wonderful opportunists. They are equally at home in a wood, a town garden or on the coast. Their diet is varied, feeding on seed, grain, insects, carrion and all kinds of rubbish that they may scavenge from rubbish tips. Because jackdaws nest in holes and cavities they are often found in the neighbourhood of cliffs. Here they find secluded nooks and crannies between the rocks where they raise their young.

The environment of the sea is not always calm, blue and peaceful. For much of the time the ocean is cold and grey as steel, with mighty rollers that thunder their way towards the coast as towering waves. It is difficult to imagine how sea birds are able to rest, preen and feed in this wild environment but many species remain at sea in the most fierce conditions. Each bird seems a tiny little speck, lost within the vastness of the ocean.

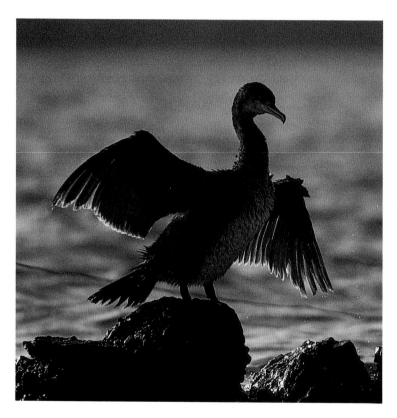

The cormorant's plumage is not as well waterproofed as many species of sea bird. As a result it is rarely found far from land because it needs to settle on a post or rock where it can preen. It then opens its wings to let the breeze dry them out.

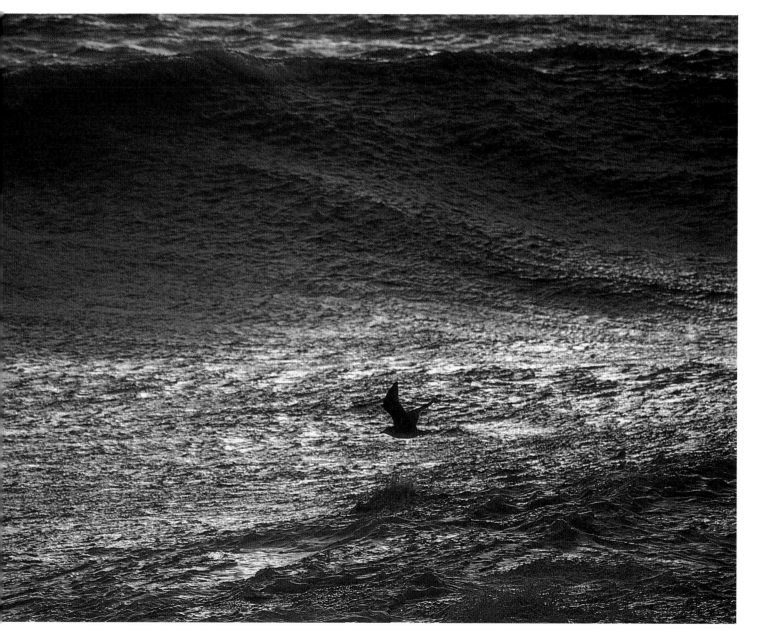

Just as it seems inevitable that a great wave will swallow the
gull, it skilfully rises over the crest and down into the next
trough. By keeping low to the surface of the water, birds avoid
the worst of a howling gale.

Salt marshes and pastures close to the sea become the home of many different species of birds, especially during the winter months. Wildfowl (geese and ducks) fly from the colder arctic regions to overwinter in our milder climate. Geese are grazing birds, and although they may feed on seaweeds revealed at low water they spend more time in nearby fields cropping the short turf. In some areas they arrive in such large numbers that they become an agricultural pest, especially when they eat root crops destined for market.

The warming effect of the sea may prevent the ground from freezing, even once it has frozen solid further inland. This enables birds such as the lapwing to continue feeding on worms, insects and other invertebrates found in the fields. During periods of hard weather there is a large movement of lapwings to the milder south-west, and huge flocks may rise from the fields when disturbed.

With its crop full, a greylag goose tucks its head under its wing, stands on one leg and rests. It could hardly be described as sleep because although the goose's eye lazily closes from time to time it still remains alert. On the basis that many pairs of eyes are better than one, large numbers of greylag geese feed and rest together, giving added security.

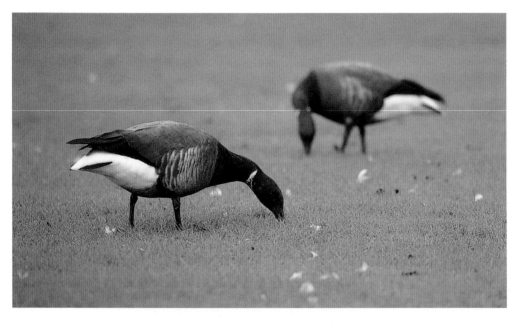

Brent geese usually feed between the tides on eel-grass or other soft, green seaweeds. Occasionally during times of food shortage they will fly inland to crop the short turf.

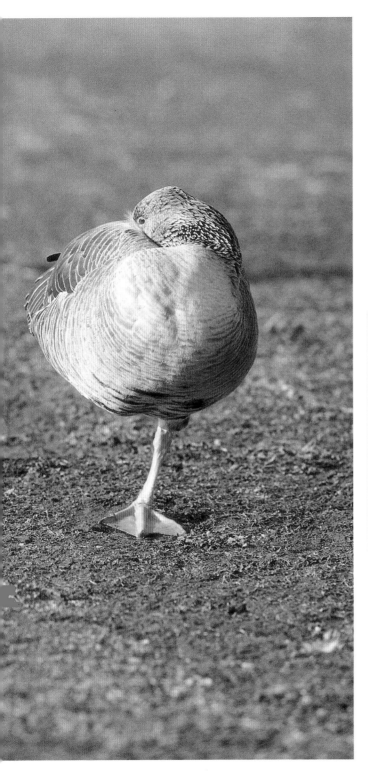

The lapwing is also know by two other names: peewit, which derives from its call, and green plover, which derives from the greenish sheen on its back. The name lapwing describes its lazy flight — with slow wing beats it seems almost wobbly in the air.

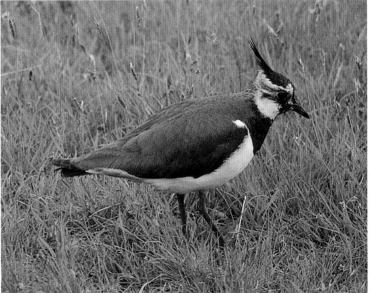

A huge bank of pebbles thrown up by the tide creates Chesil Beach in Dorset. It is perhaps the most spectacular storm beach in the country, measuring about 28km (17.5 miles) long. At its highest point it is over 14 metres and its maximum width is about 200 metres. To walk the beach is an arduous task as the smooth, round pebbles move beneath ones feet. For almost half of its distance the Chesil bank is separated from the mainland by a tidal lagoon known as the Fleet. One of the best known features of the Fleet is the Abbotsbury swannery which is home for many hundreds of mute swans.

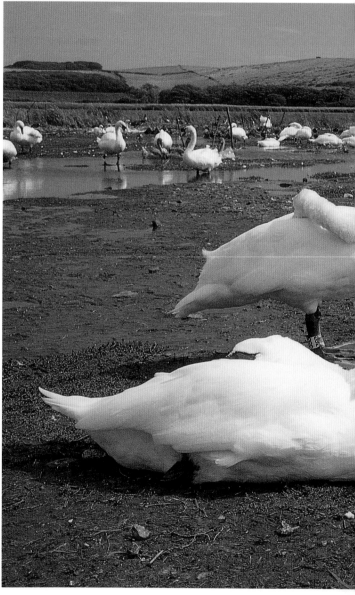

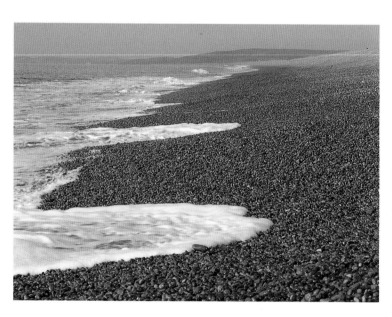

Chesil Beach, mile after mile of washed stones and pounding waves.

Although both the Bewick and whooper swans visit the British Isles during winter, only the mute swan remains here to nest and raise its young. Mute swans are the familiar birds of lakes, rivers, harbours and ponds, and have become semi-domesticated where people regularly feed them. During the breeding season swans become territorial and can become aggressive to intruders. However at the Abbotsbury swannery, the territorial behaviour is diminished so that each pair only defends a small area.

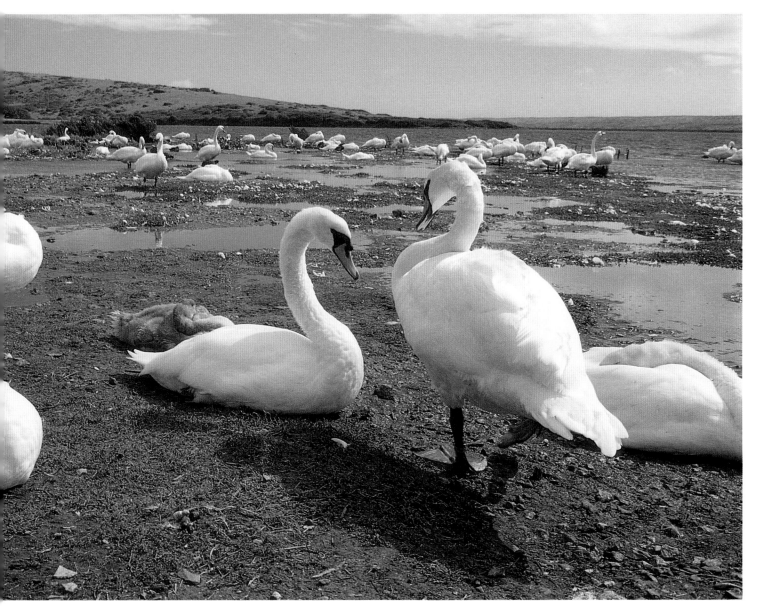

Where rivers reach the sea, unique habitats are created and one of these habitats is known as salt-marsh. Nutrients and soil particles are carried downstream by the river, and where the flow of the current is slowed down by the tide the muddy particles settle out. As more and more mud builds up, the water becomes shallow enough for sunlight to penetrate to the bottom so plants can establish themselves. At first these are seaweed-like plants but they trap even more silt until the mud is revealed at low tide. At this stage pioneer plants, such as cord grass and glasswort, become established, and they continue to trap the silt until over a period of many years only the highest tides can cover the mud. It is this area that is referred to as salt-marsh and many interesting species of plants thrive only in this habitat, including sea lavender, thrift and sea aster.

As a result of the constant rise and fall of the water level, the salt-marsh is criss-crossed with creeks and dotted with salt pans. Even these creeks have a plant population of their own, and sea purslane favours the sides of the creeks because they drain quickly.

90

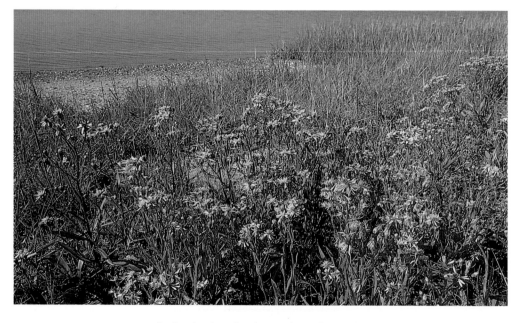

A flush of colour brightens the salt-marsh as sea asters come into bloom. They are perennial plants that are only found in this type of habitat or on sea cliffs.

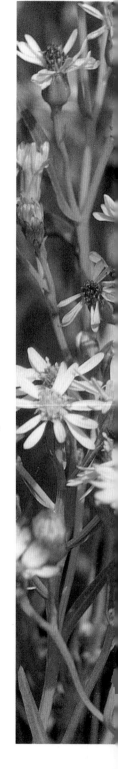

Sea asters were once cultivated as garden plants and their flowers are similar to Michaelmas daisies. They flower late in the year, even into October when few other plants are flowering. Butterflies take advantage of this late supply of food and a patch of sea asters attracts large numbers of small tortoiseshells and other autumn butterflies.

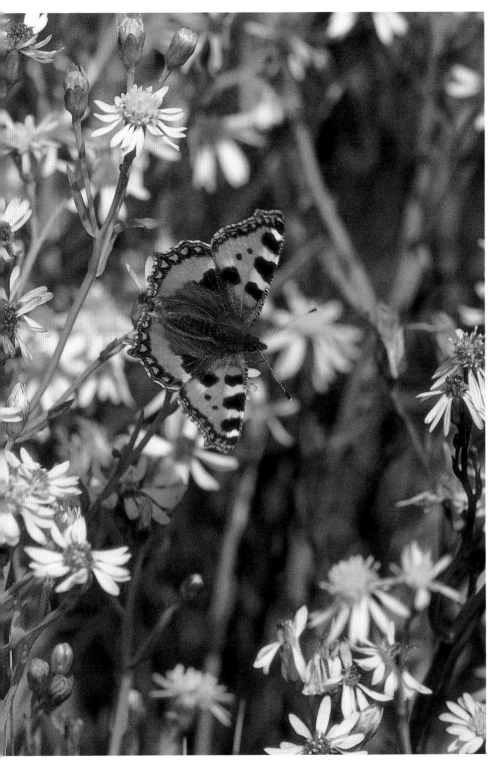

Depending on the currents, the area between the tides may be either mud or sand. A high spring tide not only covers the sand but also washes over the vegetation.

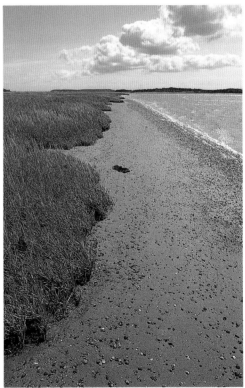

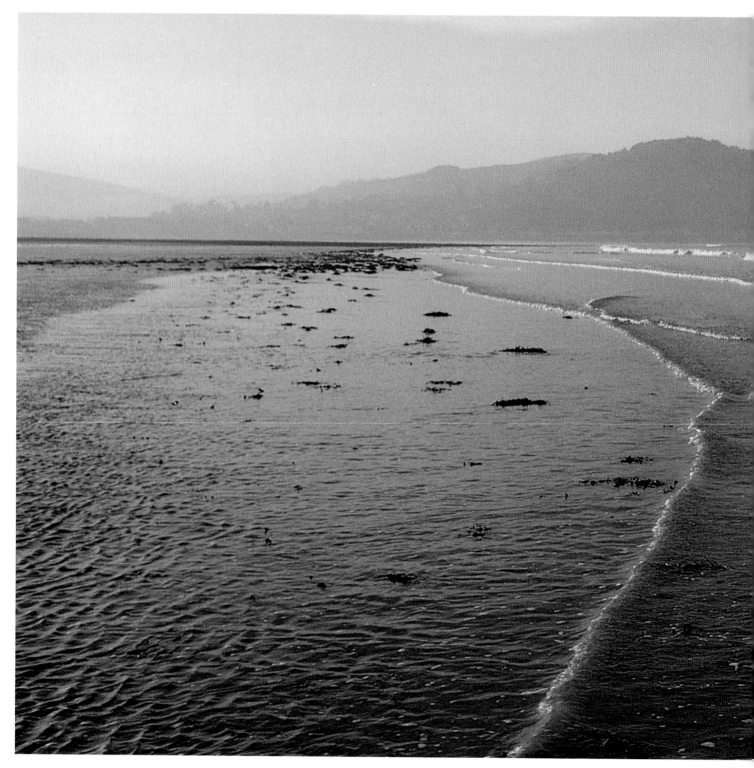

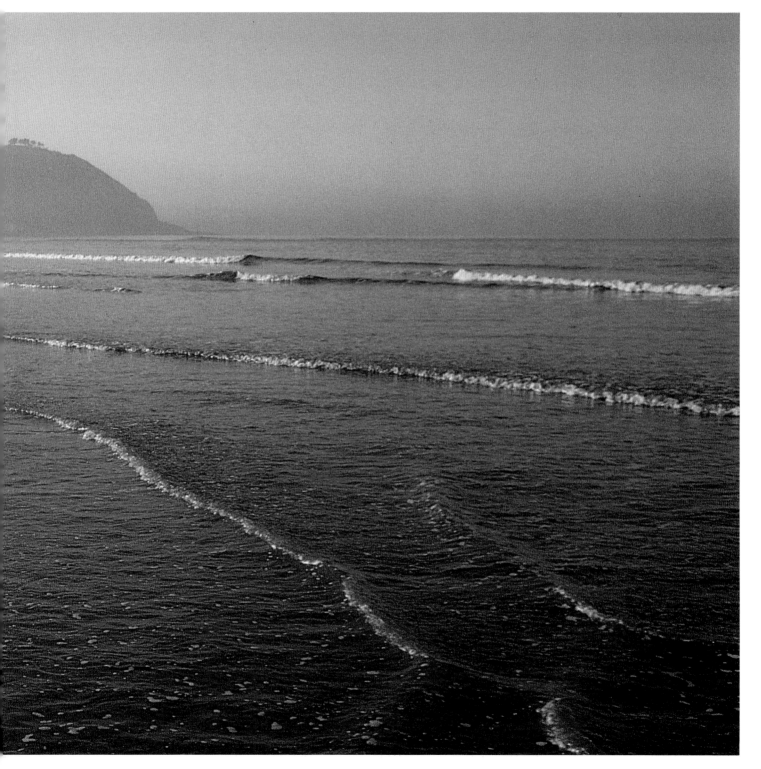

Index to Photographs

Acknowledgments

It all began as I sat across a desk from Rebecca Winter at Lion Publishing. I had suggested the idea of producing a book as a celebration of God's creation, and I proposed several chapters. Rebecca shared my enthusiasm and we agreed on a completion date. I was then taken by surprise when Rebecca asked if, rather than just one, I would photograph and write a set of four books, each covering a different environment. This was even more exciting than I had imagined and I eagerly agreed. However, the completion date remained unchanged! So began the most hectic and challenging two years of my life.

As I drove home, I worked out that I had about five hundred working days to photograph five hundred wildlife subjects, and to write text and captions. The four environments I selected were coast, woodland, river and garden, and during the following two years I travelled from the most northern tip of Scotland to Welsh islands, and from the east coast to the south-west tip of England.

The photographic equipment I used included two single lens reflex camera bodies and four lenses — 28mm wide angle, 50mm standard, 105mm macro and 300mm telephoto. Extension tubes, three flash units and cables were the main accessories and every picture was taken using a substantial tripod.

Wildlife photography is more to do with understanding the subject than equipment, and making use of that knowledge to get in close or encouraging the subject to behave in the way you want. Almost all the bird photographs were taken using a hide and small subjects such as insects or mice were photographed in my studio.

Finding some subjects is one of the most time-consuming occupations, and working on private land is a real bonus. As a result I am extremely grateful to the many farmers and land-owners who generously allowed me access to their property. I lost count of how many private gardens I visited for the 'garden' book, and I am so appreciative of the welcome and help I received from people who share my interest in natural history. It is always encouraging when someone else shares your enthusiasm for a project, and I am grateful to C.J. Wildbird Foods Ltd. for providing me with a supply of food to tempt everything from blue tits to badgers, woodpeckers to wood mice.

I also wish to thank the whole team of Lion Publishing who have been not only professional and efficient in their approach but also enthusiastic, which makes them a pleasure to work with.

During the two years I spent working on this set of books I needed to spend many days away from home and usually worked very long hours. Throughout, my wife Janet was always encouraging, sharing my failures and frustration as well as my success and without her support it would have been impossible. To say that I am grateful seems inadequate.

Text and pictures copyright © 1996 David Boag

This edition copyright © 1996 Lion Publishing

The author asserts the moral right to be identified as the author of this work

Published by
Lion Publishing plc
Sandy Lane West, Oxford, England
ISBN 0 7459 3173 1
Albatross Books Pty Ltd
PO Box 320, Sutherland, NSW 2232, Australia
ISBN 0 7324 0877 6

First edition 1996

10 9 8 7 6 5 4 3 2 1 0